GALVESTON
SEAWALL CHRONICLES

KIMBER FOUNTAIN

THE
History
PRESS

D1208251

Published by The History Press
Charleston, SC
www.historypress.net

Front cover, top: Photo by the author (*left*); Courtesy of Galveston Island Beach Revue/
Candace Dobson (*right*).

First published 2017

Manufactured in the United States

ISBN 9781467137898

Library of Congress Control Number: 2016961713

Notice: The information in this book is true and complete to the best of our knowledge. It is offered without guarantee on the part of the author or The History Press. The author and The History Press disclaim all liability in connection with the use of this book.

For GALVESTON, MOM and M. LUDWIG

CONTENTS

ACKNOWLEDGEMENTS

First and foremost, my unequivocal appreciation is extended to John Frank Hall, owner and publisher of *Galveston Monthly* magazine. This book all started with John's idea, and it would not have happened without him. He pitched the concept of a year-long series on the seawall to me in a content meeting for the magazine, and I was instantly taken with the idea. From there, it morphed into this book, for which John also generously provided the images from the original magazine series via the Rosenberg Library, as well as many others that were not published. For the opportunity he has given me, and for his constant encouragement and support, I hold a level of gratitude that is hard to express, even for me.

A special thank-you to Tena and Louie Jerger of the *Island Guide* publication in Galveston for giving me my very first writing job.

To the remarkable staff at the Galveston and Texas History Center at the Rosenberg Library, Travis Bible, Casey Greene, Sean McConnell and Peggy Dillard, I extend my unending gratitude for their knowledge, patience, assistance and especially their passion for Galveston history.

To The History Press, for letting me tell this story and for the willingness to embrace a first-time author, for the ease of your processes and your well-established integrity, I am honored to be on your roster. Most notably, I would like to thank Ben Gibson, commissioning editor, who enthusiastically championed this concept and provided guidance along the way.

Thank you Bob Whelton, Henry Freudenberg, Doug McLeod, George Lestos and Steve Keys for the generous donation of their memories to this

Acknowledgements

story, and a special additional thank-you to Bob for allowing me access to his personal collection of photos.

Personally, I must acknowledge my mom, who instilled in me a love for literature; my dad, whom I love so dearly; Maura Ludwig, who knew I was a writer way before I did; and Stephen Gerald, who was one in a million. Eric, I love you. Krissie and Kelly, I am so glad you are my sisters.

To Galveston, what an entrancing city you are. I am forever mesmerized by the strength of your people, the beauty of your culture, the diversity of your lifestyle and the music of your art. Your existence is an inspiration.

To Chicago, my person transformed at the sight of that skyline, within the unlimited city limits I found wisdom, truth and peace. And to my glorious, beloved Cubbies, 2016 World Series champions, I was finishing my first book while they were making history—it doesn't get more poetic than that.

And lastly my muse, my sunshine, my soulmate—my dog, Elle. You are my favorite person in the whole world.

INTRODUCTION

Galveston history is like Mary Poppins's purse—a relatively modest confine with unfathomable depth and the ability to hold an innumerable amount of secrets. At the precise moment when I think that nothing more is to be known about a subject, out pops an undiscovered file or photograph or a forgotten newspaper article. That is most likely why, after already having spent years researching Galveston's past, I felt an unbridled enthusiasm emerge when the publisher of my magazine proposed that I write a year-long, twelve-part series on the seawall. But even then I never could have imagined how much more fascinated I could become with a city that I already adored.

As my work began on the series, my excitement amplified as I came to be increasingly aware that nothing like this had ever before been written. This fact became obvious when the various pieces of information I sought were all in different places; a cumulative reference for the seawall did not exist. The material was scattered about, pieces here and articles there—memoirs, files and dissertations somewhere else. When I fully realized the uniqueness of the project despite all of the volumes and volumes that had already been written about Galveston history, I knew that this was my story to tell.

I was even more certain of my connection with the story of the seawall when I discovered that it would involve the Galveston grade raising, because the grade raising is indisputably my favorite Galveston story of all time. It features ingenuity born of unimaginable heartbreak; genius that would have been nothing without a symbiotic willingness to endure unthinkable

inconvenience; and drama, collective triumph tinged with the sting of personal defeat. And every last person who sacrificed their comfort for seven years did so for people they would never even meet—people like me and each of the millions of people that still visit Galveston every year.

People walk, bike or drive down Seawall Boulevard, and many of them do not realize that they are standing, pedaling or cruising on top of a mind-blowing century-old feat of civil engineering. This is completely understandable; human nature possesses a tendency to think that the way things are is the way they have always been. The seawall's story has given me the opportunity to shed light on this forgotten mathematical marvel.

It has also allowed me a chance to address a significant misconception among modern Galveston historians. When telling the story of the city's prosperity during the late nineteenth century to a modern audience, naturally some sort of connection must be established between then and now. Then, it was opulent commercial buildings and million-dollar mansions. Now, Galveston is seen as predominantly a tourist town, and the mansions are museums. Within my experience, the only explanation ever given for this discrepancy has been the Great Storm of 1900. It killed thousands of people, many more abandoned the island in the aftermath, the damage was horrendous and Galveston's port would never make money again. Indeed, all of that is true—except the last part.

Imagine pulling back a rubber band and then releasing it. The more it is pulled, the farther it flies. Now imagine a group of entrepreneurial minds that managed to take a thirty-two-mile-long barrier island and turn it into one of the largest grossing commercial ports in the world coming up against utter annihilation. These were not the sort of men who were about to cower and concede. In the initial years after the 1900 storm, Galveston broke every commercial record it had ever set in the century prior—more than once. When historians say that the storm was too much for Galveston to bear, not only do they deny the city its just due but they also deny audiences one of the most powerful stories of the strength of the human spirit that has ever been told.

In this vein, another interesting facet of Galveston's history that the story of the seawall brings to light is how the local tourism industry was formed—accidentally. At the time the wall was built, Galveston was amid the aforementioned heyday, and the only thing local officials and businessmen were looking to diversify was the port's portfolio of imports and exports. No one decided that the city should try to attract tourists as a way to expand its economy, and no one thought of the seawall as anything more than a

protective measure. Only after it was constructed did the city realize that it was much more than a wall, and only after the Port of Houston opened in 1914 did the city realize that it had literally paved a path to a new future.

Even still, Galvestonians could not have known exactly what that future would become. They could not foresee that their beloved wall would one day open a picture window into the history of a nation or provide an intriguing shadowbox of the ever-evolving lifestyles of twentieth-century Americans. Decades have a tendency to categorize themselves by way of fashion, political movements, music and entertainment. Galveston's beachfront embodied them all and made it look effortless. Most importantly, no matter what was happening around the country, Seawall Boulevard could be relied on to provide a cornucopia of delight and delicious distraction. During times when the rest of the world was taking itself very seriously, the seawall's bubble bounded through time and space as a reminder to always find the fun.

DEVASTATION GIVES RISE TO DETERMINATION

When one considers the many difficulties that have been encountered and successfully met, it must be admitted that nothing can keep back a united people who are determined to succeed.
—*Edmond R. Cheesborough,*
secretary of the Galveston Grade Raising Commission[1]

The city of Galveston, located on an island of the same name, was among the first prominent wealthy cities in the United States. Incorporated in 1838, this small island town off the coast of Texas took full advantage of its natural harbor, which begat an easily accessible port of commerce. Toward the end of the nineteenth century, it even surpassed Ellis Island as the largest center for immigration in the United States. As a fierce entrepreneurial spirit invaded the city, so did the influences of cultures from around the world, and Galveston was home to a diverse, open-minded and ever-expanding population amid the throes of a conservative Victorian era.

The miles of temperate beaches along the southern edge of the island were merely an accessory in the early days of Galveston, a tiara amid the queen's collection of crowns. Visitors would often supplement their schedules with bathing in the calm and tepid waters of the Gulf of Mexico or strolling down the sandy shores, but the main allure of Galveston in the

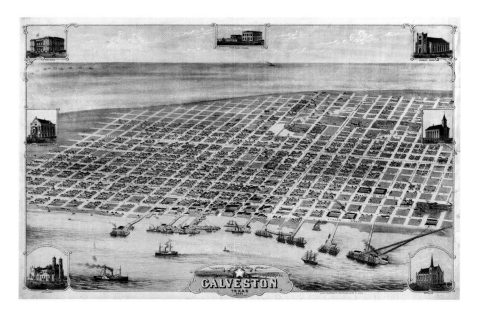

This early depiction of Galveston Island was drawn looking south, with the far eastern border of the city on the left. *Rosenberg Library.*

nineteenth century was the vibrant downtown, located on the opposite side of the island.

The eastern portion of the island's northern border along Galveston Bay was the highest point of elevation at the time of the city's founding. Conveniently, it was also adjacent to the natural harbor created by the island's proximity to another landmass in the bay, Pelican Island. Capitalized on long before it became the original city limits of Galveston, this area along the harbor was a haven for the pirate Jean Lafitte and later used by Mexican traders before Texas gained its independence. Official city status created the Port of Galveston and catapulted the modest outpost into a burgeoning center of international activity.

By the 1880s, Galveston was the largest city in Texas and boasted an economy that exchanged over $38 million.[2] Cotton production in Texas verifiably boomed after the Civil War, and the sale and export of the fiber through the myriad commission houses and merchants along Galveston's Strand Street lined the pockets of local businessmen. The Strand was dubbed the "Wall Street of the South," and by 1898, Galveston had become the second-richest city in the nation per capita, surpassed only by Providence, Rhode Island—the home of the Vanderbilts.[3]

This gave way to flourishing dry goods businesses, countless banks and an entire block of insurance companies; the money made in Galveston was made twice over. Stunning architecture, palatial homes and all of the most modern technologies were commonplace. The city's downtown area along the harbor was teeming with the finest European restaurants, luxurious accommodations, world-renowned entertainment and countless amenities. By water or by rail, travelers poured in to revel in the marvels of a major city. Many of them stayed, seeking their own niche in a seemingly infinite market. By all accounts, the city was invincible, cloaked in an impenetrable shroud of optimism and hope.

But precarious was its perch in the Gulf of Mexico, and as a new century dawned, this defiant stance against the powers of nature would be severely examined. On September 8, 1900, a hurricane with estimated 120-mile-per-hour winds and a storm surge that reached a documented 15.7 feet struck the unsuspecting island community, and the "Queen City of the Gulf" was brought to her knees.[4]

Known today as the Great Storm of 1900, this event stands as the deadliest natural disaster in the history of the United States; the actual number of deaths will never be known, but an estimated eight to ten thousand people

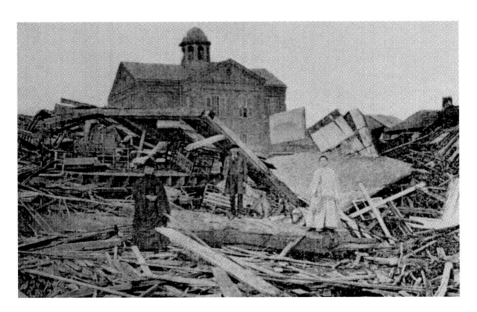

During the Great Storm of 1900, the Gulf of Mexico invaded the island, leveling nearly three thousand homes and piling them into a wall of debris. *Rosenberg Library.*

lost their lives lost in one city, in one night. The next morning, bodies were everywhere, buried under debris and strewn about the city, and the devastation wrought from loss of life was further amplified by the near-apocalyptic destruction of the heart of the city.

Moving water is the most powerful force on earth, and as the Gulf of Mexico plowed its way in from the beach at the behest of hurricane force winds, it laid to waste 2,636 buildings and homes,[5] tearing them from their foundations and pushing them into a twenty-foot-high, three-mile-long wall of rubble. The wall started at Eighth Street and the harbor, encasing downtown in a semicircle that continued all the way around to Twenty-Seventh Street and the harbor. Two-thirds of the island was scraped clean. But the unrelenting Neptune ultimately checked himself, and the wall of debris became too large even for a storm of this magnitude. Thereafter it became a breakwater and served to protect the downtown commercial district from the fate of the homes along the shoreline.[6]

Despite this fortuitous irony, which spared much of the city's opulent architecture, downtown was not exempt from the near-sixteen-foot storm surge that invaded from the bay side, swallowing the Strand and purging the contents of the buildings into the all-consuming sea. The wind sheared the upper floors from many of the grandiose buildings and sent their slate shingles and artisan brick hurling through the air like shrapnel. In one day, Galveston was removed from its pedestal of prosperity and flung into the depths of unparalleled misery and ruin.

Notwithstanding the wealth of the city's economy and many of its residents, the local government had been in state of disarray and lacked leadership long before the storm hit Galveston. The mayor at the time of the disaster, Walter C. Jones, was not entirely inept and ineffective in his duties, but he certainly had the reputation of being so. City financial records were practically nonexistent, and many landowners and city officials used this knowledge to their advantage and rarely paid their taxes. The City of Galveston was bankrupt, and its bonds were severely depreciated with no hope of releasing more, especially in the current state of things—no matter how desperately the city needed to finance its recovery.[7]

Behind the scenes, a select group of Galveston's elite looked on the coupling of this mass governmental chaos with abject devastation as the perfect opportunity to initiate much-needed progress within Galveston's municipalities and administration. I.H. Kempner, affectionately known as "Ike," led the charge and was an outspoken advocate for implementing drastic changes that would ensure the future of the city.

Unabashed in his attempts to sway public opinion, Kempner prompted and encouraged residents to believe wholeheartedly in his vision for the future of Galveston. He coined the phrase "Spirit of Galveston" as a reflection of the tenacity displayed by the survivors of the storm and used it as a catalyst to encourage people to stay and rebuild. He also stoked the political fire under his peers and inspired them to join in his efforts to reform the city government.

The prominent businessmen of Galveston were no strangers to joining forces. Their cumulative efforts in the late 1800s had formed several organizations in an attempt to sway regulatory practices toward the interest of Galveston commerce, such as the Cotton Exchange, the Wharf Board and, most notably, the Deep Water Committee, from which Kempner derived most of his allies. Originally created to garner federal support and funding to deepen Galveston's connecting waterways, the Deep Water Committee remained an influential ad hoc group even after its initial purpose was exhausted.

Under Kempner's leadership, many members of the Deep Water Committee again coalesced to form a political party called the City Club. They petitioned the state government to annul the current city charter and set in place the New City Charter, a highly progressive comprehensive approach to rebuilding the city from the inside out.

In an unprecedented move, the New City Charter first changed the format of the city's governing body, restructuring it to resemble a business governed by a board of directors. It consisted of one mayor/president and four city commissioners, each of whom would oversee a designated function of the city's operations. The original charter stated that the governor would appoint both the mayor/president and the commissioners, prompting a steadfast Kempner to travel to Austin on many occasions to win the favor of state officials. Unfortunately for Kempner and his associates, the Texas Congress deemed the governor's involvement unconstitutional and required that all of the commissioners be decided by popular vote.[8]

Nevertheless, the City Club's innovative approach to city government was widely applauded by the state's elected representatives, and upon returning to Galveston, Kempner and his men were equally as successful in wooing the city with their far-reaching ideas. In the first general election, the City Club swept all five positions on the panel. The commission form of government would eventually be adopted by Houston, San Antonio, El Paso and many other cities outside of Texas, but this would be only the first of many times that Galveston's novel ideas would capture the attention of the nation.

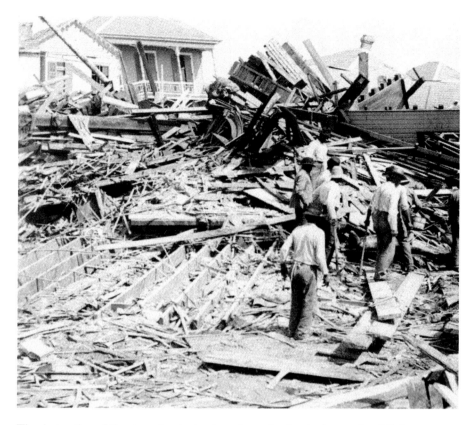

The destruction of the storm inspired a deep determination in the people of Galveston to secure the safety of their future. *Rosenberg Library*.

The New City Charter also dealt directly with recovery efforts and set forth plans and precedents for the fortification of the island. Steeped in optimism and certain of Galveston's reclamation, Kempner and the authors and purveyors of the New City Charter were adamant that all means and monies possible be expended to prevent the horrors of September 8 from ever happening again.

Their persistence struck a chord with the public, and the commonality established from suffering and symbiotic heartache transcended any doubt that the city could both rebuild and render itself immune to future storms, no matter the cost or sacrifice it required. The promise of Ike Kempner's "Spirit of Galveston" resonated with the survivors; it swept through the population and gave rise to a steely determination where before there was only hopelessness. Thousands fled, but the many who remained were willing

to endure whatever hardship was necessary to secure the safety of their beloved island home.[9]

Via the plans set forth in the New City Charter, one of the first actions taken by the newly elected Board of Commissioners was to appoint a Board of Engineers. This collection of three of the best and brightest civil engineering minds in the country would be assigned the distinct task of examining the current geological profile of the island with an express purpose of proposing a way to protect it from future storms.

The trio of Robert, Ripley and Noble was officially appointed as Galveston's Board of Engineers on November 22, 1901. General Henry Martyn Robert, who was most famous for penning the procedural handbook now known as *Robert's Rules of Order*, was recently retired from the Army Corps of Engineers and at one time had been a key consort to the Deep Water Committee as a strategist for the deepening of Galveston's harbor. H.C. Ripley was member of the Army Corps of Engineers and a Galveston resident; his familiarity with the island was crucial to the board's development. Lastly, Alfred Noble of Chicago was a distinguished and well-known civil engineer who designed the windy city's breakwater. He also contributed his talents to many federal projects and served as president of the American Society of Civil Engineers.

The three men readily accepted Galveston's offer, enticed not only by the stature and prominence of the island city but also by the sheer magnitude of the challenge before them. Per the charter, the duty of the Board of Engineers was to report "plans and specifications with estimates of the costs" for the safest and most efficient ways to protect Galveston from the merciless insurgence of the Gulf.[10] The Board of Engineers met repeatedly over the course of two months and released their report on January 25, 1902.

It amazed everyone.

A PREPOSTEROUS PROPOSITION

The celerity with which order was brought out of chaos, financial stability restored, and arrangements made for restoration and protection, is one of the marvels of the history in city governments.
—*S.C. Griffin*[1]

The board released its report fifteen months after the Great Storm, and by that time, the City of Galveston had already made triumphant strides in its recovery efforts. The rail bridge that connected the island to the mainland was completely repaired and operable eleven days after the storm passed. Within two weeks, the port was reopened. In just over one month, on October 15, over thirty thousand bales of cotton careened out of the harbor, the port's largest total to date.[2] The wall of debris was completely dismantled in three months, and all of the deceased had been collected in that time, save for the few that were waiting to be discovered months later in the marshy inlets of the west end.

Property damage both public and private was estimated at $30 million,[3] yet the Central Relief Committee—organized by Mayor Jones the afternoon of September 9 to spearhead recovery efforts—accounted in its final report a gross receipt of only $1,258,000 in donations.[4] But after six months, the city and its residents no longer depended on any outside sources for further relief. When considering the speed and voracity of Galveston's recovery in tandem with this complete lack of outside assistance, the only conclusion is that the survivors helped themselves.

Similar to Chicago, which used the Great Fire as an impetus for much-needed change and increased efficiency in its infrastructure, so did Galveston rise resplendent from the debris that consumed its city streets. Most notable in these efforts were the men of the Deep Water Committee, the Wharf Board, and the Cotton Exchange who worked tirelessly to restore Galveston's prominence as a commercial port.

Significant improvements were made at the harbor-side, including a sixty-acre covered wharf that could dock ninety vessels at one time. The wharf was lauded as one of the largest and most efficient in the entire world, primarily because of its clever and universal use of electricity. Electric conveyors could load a massive cargo ship from one of the port's grain elevators in less than one hour.[5] Thirty-five sets of railroad tracks ran along the docks, connecting the wharf to the railyard, and rail cars with electric motors propelled cargo to and fro. The tracks were controlled and changed quickly and easily with electric switches.

Beyond the rail yard, Galveston was directly linked to nine different rail lines, which led to every important hub west of the Mississippi. Galveston claimed the largest territory of any American port, which further solidified its reputation as the "Octopus of the Gulf."

Local merchants and commission houses had long been dissatisfied with limiting their exports to the cotton of Texas, especially as the price steadily decreased toward the end of the nineteenth century, requiring larger and larger quantities to turn a profit.[6] So they pursued the grains of the Midwest and the minerals of Colorado, Missouri, Kansas and Arkansas. They also sought oil and the lumber from the forests and mills of the Southwest. They went north and successfully acquired the flour trade.

At the close of the 1902 fiscal year, the Port of Galveston reported an all-time high foreign export value of $99 million. The following year, that number rose to $104 million, and Galveston was the only port in the nation that surpassed its previous high record. The port also broke every record in customhouse receipts that year as well; the total value of freight handled in Galveston Harbor through fiscal year 1903 hovered close to $400 million.[7]

Interesting things happen to the mindset of a community when complete devastation makes way for outrageous success; most notably, they become convinced that absolutely anything is possible. Amid the overwhelming success of commercial victories, the shadow of the storm weighed heavily on the city's memory. Galveston was rebuilt and thriving, but its story was no longer one of survival, it was now a tale of self-preservation. Those who

were spared their lives felt a sense of duty to the future and an unflinching desire to forever shield the island from a repeat of that September day.

Thus, the Board of Engineers presented a two-part plan for the fortification of the city to the battered but resilient population, a plan that by anyone else's measure would have been deemed irreverently audacious and utterly impossible. Yet throughout the general public of Galveston, reactions varied only from incredulous awe to shocked amazement—no one dared to doubt that it would be done.

The first part of the plan devised by the board of Robert, Ripley and Noble discussed the construction of a three-and-a-half-mile-long, seventeen-foot-high seawall. The proposed route of the wall was designed to protect the Gulf side of the island, which had proven itself most vulnerable during the storm. It would run primarily along the perimeter of the southern Gulf shore of the city proper and curve north along the island's eastern edge, ending at the harbor. "The wall will be founded on piles and protected from undermining by sheet piling and also riprap....Its width at the bottom will be sixteen feet, and at the top its width will be five feet," the report stated.[8] The face of the wall was designed to be concave to send encroaching waves upward and back onto themselves, deflecting the force of the water away from the island.

But even a magnificent wall against the sea was dwarfed by the second half of the plan, the grade raising, which presented the unimaginable proposition of elevating the entire southern and eastern portions of the city. A seawall alone would undoubtedly be beneficial in protecting the city from most storms. The Board of Engineers speculated that given the right conditions of wind and water, Galveston would effectively be placed at the bottom of a bowl. The wall could theoretically prevent the drainage of floodwaters and actually facilitate the submergence of the city instead of preventing it.

Robert, Ripley and Noble recommended the elevation of five hundred city blocks above the heights of a potentially enraged Gulf. The area directly behind the seawall would be raised a full 17 feet to match the height of the wall. Traveling inland toward downtown, the grade would slope incrementally until it reached Broadway Avenue, the major thoroughfare that ran east to west along the spine of the island. An initial steep decline off the wall would lead into a more gradual downward slope measuring 1 foot per 1,500 feet until Broadway, where the designated area to be raised would end with an elevation of 4 feet. (Because of the location of the original eastern border of the seawall, which is presently underneath Sixth Street,

the residential area now known as the East End Historic District was also included in this plan.)

Attached to the report were specific instructions and specifications for the construction of the seawall, written by the Board of Engineers and so detailed and precise that the trio was renamed the Seawall Board and enlisted to oversee the wall's construction. However, the grade raising was a task that surpassed even the formidable intelligence of Robert, Ripley and Noble, as they had not the slightest notion of how it would be achieved.

Even still, the plan met with no opposition. Despite the odds and uncertainty that hovered on the brink of the seawall's future completion, Galveston's Board of Commissioners and its faithful followers silently ushered forth an unshakable faith in their future. The proposed plan of the Board of Engineers was executed almost immediately, leaving the logistics of how the city and the board would fill in behind the seawall to be determined later. After all, an even more daunting problem was before them, one that demanded immediate attention: no one had any idea how the city would pay for it.

The Board of Engineers estimated that the combined cost of the construction of the seawall and the grade raising would total $3.5 million, a staggering sum for a city government still very much in financial recovery. The enterprising and resolute Ike Kempner stepped forward yet again with an answer: perhaps the county would back the bonds needed to raise the money for the project.

Galveston County was not bankrupt; in fact, it was in great financial shape. Furthermore, Galveston residents accounted for over 85 percent of the county's tax base,[9] a persuasive statistic. The Galveston Board of Commissioners presented its request on February 3, 1902, and county officials were easily compelled to offer their full support. Galveston County would back the bonds needed for the $1.5 million required to build the seawall.

For the additional $2 million needed for the grade raising, the Board of Commissioners devised a clever solution that would repurpose an earlier generous display from the State of Texas. A few months after the storm, the state passed legislation known as the Act of 1901, a tax levy that provided for the donation of portions of certain state taxes to Galveston for the city's recovery. The Board of Commissioners would lobby for extensions of the act, and between 1903 and 1919, four additional acts were passed that extended this assistance for a total of thirty-seven years. However, instead of being directed toward recovery efforts, these later acts stipulated that the

monies were to be placed into a sinking fund. This fund would back the interest payments for $2 million in bonds that the city would eventually issue to finance the grade raising.[10]

The collective result of these two resolutions was a resounding victory for securing Galveston against future calamity. The county's backing guaranteed the inevitability of the first half of the plan, while the state's aid infused stability into the city's coffers. By the time the seawall was completed, Galveston's financial situation would be so remedied as to allow for the autonomous financing of the grade raising. This also meant that one of the most monumental feats of civil engineering in the history of the United States would ultimately be accomplished without any federal assistance.[11]

HOW TO BUILD A WALL OF WONDER

Protection from storms is not only required for the preservation of life and property, but also, and in hardly less degree, to give confidence to the people of Galveston, and to others who may be drawn here by business interests, in the absolute certainty of the safety of the city against the re-occurrence of such catastrophe as the one of 1900.
—*Board of Engineers official report*[1]

With financing securely in place for both the construction of the seawall and the subsequent grade raising, preparations commenced on the first phase of the plan devised by the Board of Engineers.

The now renamed Seawall Board plotted the path of the original wall to run in an L shape from Eighth Street and the harbor around to Thirty-Ninth Street and the Gulf. The shorter leg of the wall would curve from its starting point at the harbor and run the length of Sixth Street north–south, which was the far eastern border of the inhabitable part of the island. The only notable landmarks beyond this line were the South Jetty and its rail tracks that traveled out to Fort San Jacinto, built at the turn of the century on land granted to the federal government by the Galveston City Company. Located on the farthest eastern point of Galveston Island, all that lay between the fort and the future wall was a soggy marsh referred to as the East End Flats, considered worthless.

This stretch of the wall along Sixth Street covered the short width of Galveston Island from the harbor to the beach, connecting two points that

were the north and southeast corners of city proper at the time. The wall would then curve gently around the intersection where Sixth Street met the beach, and the long arm would run continuously in a westerly direction along the southern Gulf shoreline, ending at Thirty-Ninth Street.[2]

Prior to construction, four sets of railroad tracks were laid along this proposed route to cleverly facilitate ease and efficiency in the building of the seawall. They were connected to the tracks that ran along the harbor to the railyard, and cars could be loaded up with materials and expediently delivered to work sites anywhere along the wall. The tracks could also accommodate two movable cement mixers: a small one for the foundation and a large one for the upper portion. In less than two years, this short stretch of railway would convey 5,200 loads of crushed granite, 1,800 loads of sand, 3,700 loads of granite riprap, 4,000 loads of wooden sheet pilings, 1,000 loads of concrete, 1,200 loads of round wooden pilings and another 5 of reinforcing steel.[3]

On October 27, 1902, the first piling of the future seawall's foundation was driven into place at Fifteenth Street at the wall's approximate midpoint. This was nearly a month after construction was scheduled to begin due to a delay in the delivery of timber from Beaumont that was to be used for the foundation.

Per the board's detailed instructions, the seawall's groundwork would be completed in its entirety before construction on the upper portion began. The foundation measured sixteen feet wide and consisted of seven parallel rows of pilings that would be driven into the ground perpendicular to the beach, along the line of the future wall. A steam-powered pile driver took roughly twenty minutes to force each individual piling down to the barrier island's hard clay foundation.

Four of the rows were set three and a half feet apart and consisted of round pilings cut from Texas longleaf yellow pine from Beaumont that measured a foot across and forty-five feet long. The pile driver hammered the remaining three rows directly behind the front row of pine along the beach. Three sets of twenty-four-foot planks would reinforce the round pilings and help prevent the future undermining of the foundation.

Four machines manned by ten men apiece worked continually and only stopped when either the dark or the weather prevented them. Other workers followed behind the pile drivers and dug three-foot-deep trenches around the pilings that were filled with concrete to form the upper foundation.

The small cement mixer was placed on a platform with wheeled feet that bridged the sixteen-foot span of the foundation. The concrete was made

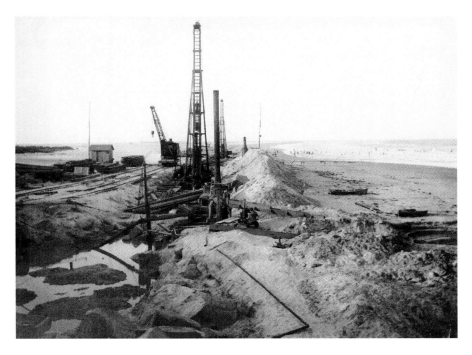

Steam-powered pile drivers hammer the pilings of the seawall's foundation. *Rosenberg Library*.

of a mixture of crushed granite, cement, sand and water and loaded into the mixer from cars on the adjacent railroad tracks. The platform was then manually pushed along the foundation to efficiently deposit the concrete directly into the trenches below. While the concrete was still wet, ten-foot-long reinforcing steel rods were stuck down into the foundation at four-foot intervals, about eight feet deep. The remaining lengths of the rods were left exposed above ground to fortify the connection between the foundation and the upper wall.[4]

While the foundation was nearing completion, loads of granite began to arrive from a quarry west of Austin, over two hundred miles away. The instructions set forth by the board specified that a wall of granite riprap should be laid at the toe of the seawall before construction was started on the upper portion. Once completed, the granite riprap would protect both the seawall and the beaches; it would diminish the force of waves upon the wall and also prevent erosion.

The board's guidelines to the quarry for selecting the granite rocks were specific: one-fifth were to weigh in excess of one thousand pounds, and at least

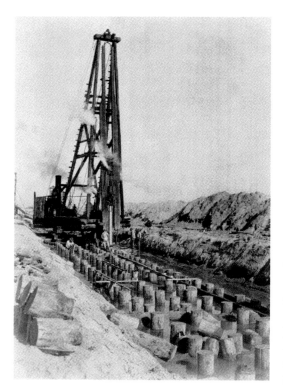

Left: The foundation consisted of seven rows of pilings: four rows of round pine and three rows of sheet piling. *Rosenberg Library*.

Below: Workers dug three-foot trenches around the pilings and then filled them with concrete from a mixer attached to a movable platform. *Rosenberg Library*.

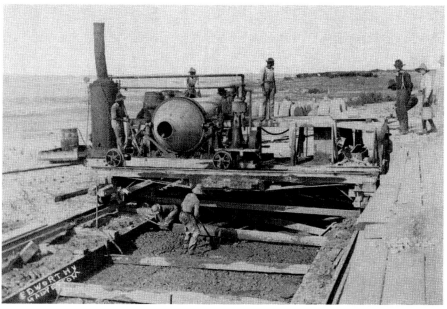

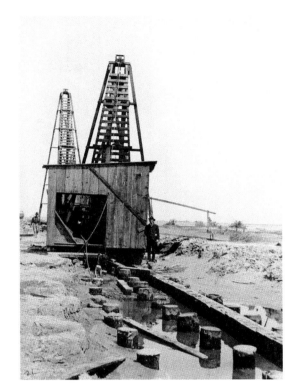

Right: Four pile drivers manned by ten men apiece worked continually. Each piling took roughly twenty minutes to put into place. *Rosenberg Library*.

Below: After the foundation was completed, a twenty-seven-foot apron of granite riprap was laid on the beach side of the wall. *Rosenberg Library*.

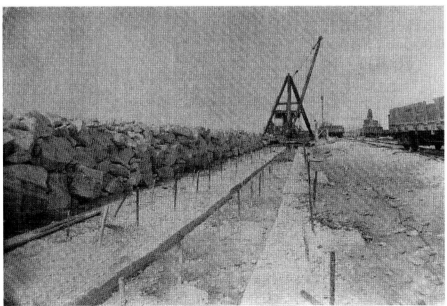

half were required to weigh a minimum of two hundred pounds and nothing less than eighteen pounds was to be used. A massive steam-powered crane was used to move the granite from the railcars to the toe of the seawall to form a twenty-seven-foot apron of rock between the wall and the beach. The largest pieces of granite were placed at the bottom, and smaller ones were used to fill in to create the most solid buffer possible. The riprap was also used to anchor the wooden structures that would frame the upper portion of the wall.

Rising seventeen feet above the foundation this upper portion was the final and most difficult step in the construction of the seawall. Designed to be sixteen feet across at the base and five feet across at the top, the wall would scoop inland to create a concave surface facing the water. The quarter-pipe shape was formed by first building massive wooden molds into the shape of the wall, and then they were filled with concrete. The granite riprap was used to brace thick wooden beams against the molds in order to secure them and prevent expansion or movement while they were being filled.

The large concrete mixer used for the upper portion of the wall was more than twice the size of the mixer used for the foundation and towered over

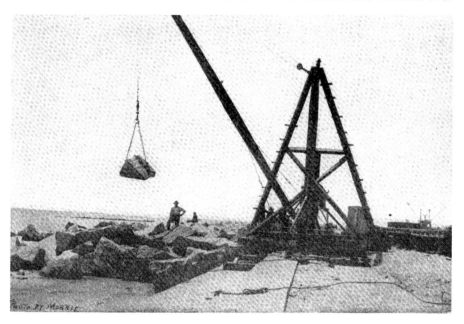

Massive steam cranes were used to place the large pieces of granite to form a solid buffer of rock for the wall's protection. *Rosenberg Library.*

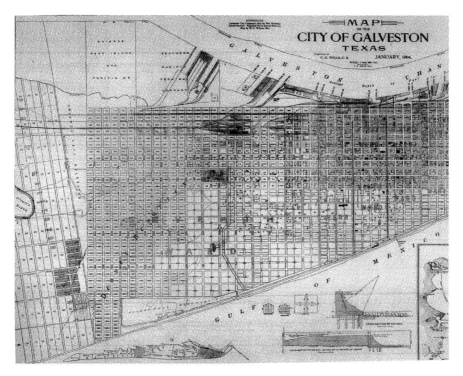

A 1911 map showing the original path of the seawall that ran south down Sixth Street and then curved westward at the shoreline. *Author's collection.*

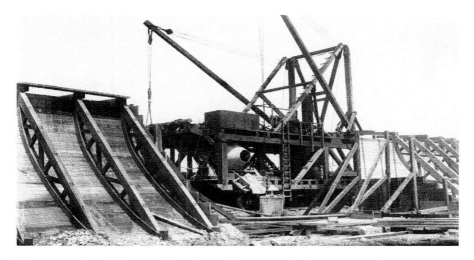

The concave face of the seawall was formed by constructing large wooden frames that molded the concrete into shape. *Rosenberg Library.*

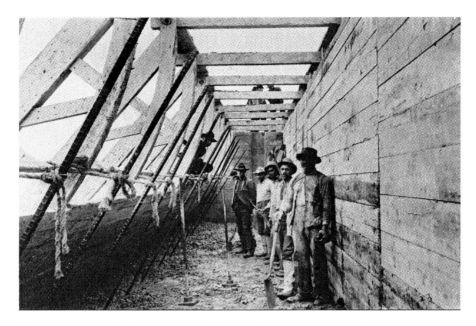

Workers pose from the interior of one of the wooden frames. *Rosenberg Library*.

the seventeen-foot frames. It was mounted atop a moving platform on the set of railroad tracks closest to the wall. Two mechanical arms stretched out from the platform on either side of the mixer. One arm swung away from the wall and toward the other sets of tracks and was used to transport the ingredients for the concrete from the railcars into the mixer. The other arm swung toward the wall, dumping the freshly mixed concrete into the wooden frame below.

Since the concrete took seven days to dry, and in an effort to prevent damage as the concrete settled, the upper wall was not built continuously like the foundation. Instead, it was built sixty feet at a time at a rate of one section per day—but never two sections in a row. A section would be completed, and then every other sixty-foot section would be built from there, seven at a time. Then the workers would backtrack and fill in the gaps that remained between the sections that were already constructed. Each individual section had alternating tongue-and-groove joints built into the interior of the wall to reinforce its connection to the adjacent section. This method of construction was also implemented to ensure the future integrity of the wall. The segmented wall would be flexible, giving it the ability to absorb the natural contractions and expansions that were bound to occur over time.

This large contraption set onto railroad tracks was designed to allow fresh concrete to be mixed on site and poured immediately into the seawall frame. *Rosenberg Library.*

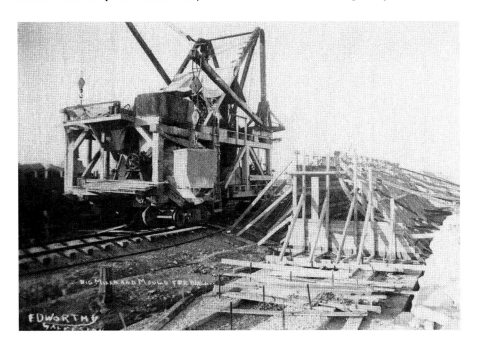

Used for the upper portion of the wall, the enormous cement mixer dwarfed the seventeen-foot-high wall. *Rosenberg Library.*

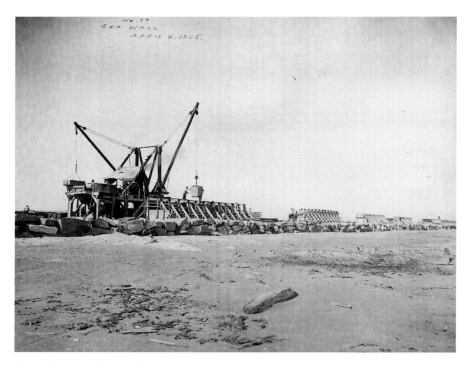

Above: The seawall was built in alternating sections to allow for flexibility and ensure the future integrity of the structure. *Rosenberg Library*.

Opposite, top: Efficient and continual construction allowed the wall to be completed in just twenty-one months. *Rosenberg Library*.

Opposite, bottom: So impressive was the seawall's design that the federal government soon commissioned this extension in 1905 to protect Fort Crockett. *Rosenberg Library*.

The original portion of the seawall was completed on July 29, 1904, a mere twenty-one months from the day construction began. It extended nearly eighteen thousand feet, or just under three and a half miles, and it weighed an estimated forty thousand pounds per foot.

So magnificent was the form and so efficient was the construction that the federal government would soon finance a westward extension to protect Fort Crockett, located on the beachfront at the far west end of the city. It was eventually extended eastward from the curve at Sixth Street as well and the area behind it filled in to create more viable property on the east end of the island. The original part of the wall that ran along the eastern edge of the city is now entombed underneath Sixth Street and the foundations of the University of Texas Medical Branch.

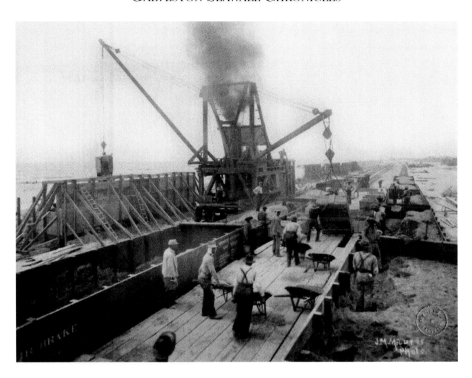

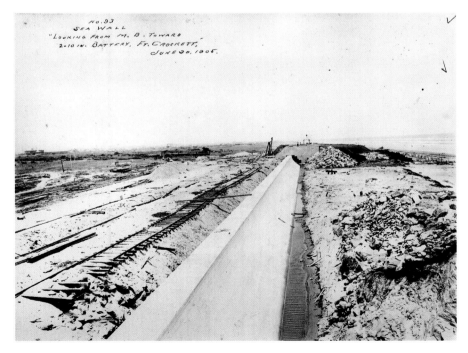

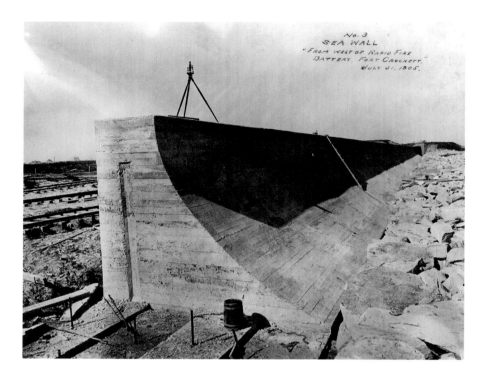

A completed section of the seawall from the 1905 extension. *Rosenberg Library.*

However, the seawall would have to wait no length of time to become a Galveston attraction all its own, already a marvel in its original form. People from across the state were eager to promenade along the magnificent sidewalk and behold the spectacular view of the Gulf of Mexico. A monument commemorating the seawall and future grade raising was installed on the wall at Twenty-Third Street between Breakers Bathhouse and Murdoch's Bathhouse, both of which were destroyed in the 1900 storm but fearlessly rebuilt on the beachside in anticipation of the wall's completion.

But even before the first person took an elevated stroll along the Gulf shoreline, Galveston had already come face to face with the impending reality of step two—the grade raising. The seawall's ability to deflect the Gulf waters was obvious, but also obvious was the fact that the city was trapped at the bottom of a seventeen-foot-tall barrel. A significant storm surge could be deadlier than the one that inspired the wall's construction. Galveston Island's position on the water was more vulnerable than ever, and the ingenuity and genius it was going to take to finish the task had yet to be discovered.

REACHING NEW HEIGHTS

THE GALVESTON GRADE RAISING

*If we are fortunate enough to make a satisfactory contract it is our purpose
to appeal to the patriotism and forbearance of these citizens and ask for their
active cooperation, without which our task will indeed be most difficult as well
as unpleasant. When the work is in progress those residing in the section being
filled will undoubtedly be put to a great deal of inconvenience and annoyance,
as well as some expense. This, however, is what must be expected; but there is a
consolation in knowing that when it is all over we will be more than compensated
by the increased value of our property, the absolute safety of our houses, and the
beauty of and inestimable general benefit to the city.*
—Captain J.P. Alvey, chairman of the Grade Raising Commission[1]

The people of Galveston had marveled at the ingenious plan set forth
by the Board of Engineers, but now they began to grow anxious as the
seawall neared completion and they were confronted with the mystery
of how the grade raising would ever be possible. The New City Charter
did include instructions for the administrative processes of the task, but
ultimately, that only meant that city officials would delegate the intricacies
to others more qualified.

The charter stated that the "Governor of Texas shall appoint three
resident citizens and qualified voters of the city to serve on a board for the
comprehensive management, control, and direction of raising and filling
the proposed areas," although all of their decisions, provisions and contracts
were to be approved by the Board of Commissioners. On May 15, 1904,

Texas governor S.W.T. Lanham complied and officially named the Galveston Grade Raising Commission.

Captain J.P. Alvey, an influential and well-known businessman, was appointed chairman of the board. The general manager for two prominent local businesses, the Texas Guarantee and Trust and the Texas Land and Loan Company, Captain Alvey was long associated with port commerce and an active advocate for its expansion. At the time of his appointment, he was also serving as a member of the board of trustees of Galveston's public school system.

Perhaps the most enduring name on the commission's roster was the ubiquitous John Sealy. His father was one of the founding members of the first bank in Galveston, Hutchings & Sealy & Co., and John was well on the path to expanding the family fortune. He was president of the Wharf Company, served on various boards around town and donated the instructional hospital building that would become the University of Texas Medical Branch, one of the leading research and teaching hospitals in the nation.

The final member, Edmond Cheesborough, was elected secretary at the commission's first meeting and proved most adept in his duties. A diminutive man with an organized and efficient manner, he well suited the board's needs with a résumé that included Galveston postmaster, secretary of the Blum Land Company and secretary-treasurer to the Texas Cement Company. Cheesborough's thorough and immaculate execution of his position of secretary has provided history with seven years and hundreds of pages worth of documentation on the acts and activities of the Grade Raising Commission.[2]

The members of the grade raising board, each firmly established in their professional and personal reputations, still had little more than a vague notion of where to find the answers to the prospect of elevating over two thousand structures and filling underneath them. The most glaring speculation was how and whence they would obtain the estimated seventeen million cubic yards of fill needed for the project. Bringing it in from the mainland would be incredibly expensive, dredging it from the Gulf of Mexico could negatively impact the beaches and taking it from the west end would prematurely halt Galveston's only path for expansion.[3]

The board opened the discussion up to the public and vetted many suggestions and probable solutions yet at last wisely surmised that contractors who were actually able to perform the task at hand were the best source for a solution. The decision was made to issue a nationwide call for bids from

contractors, outlining only the specifications for the amount of fill and land to be filled. They would leave the details of the source of the fill and the method of distribution up to the bidders' creativity. The contract would be awarded to the firm or individual who presented the most efficient and cost-effective plan.

In order to properly ascertain the scope of the project for possible contractors, the board hired Captain Charles S. Riche, head of the Government Engineers office in Galveston, to provide a precise calculation of the amount of fill that would be needed. Riche hired H.T. Wilson to conduct a thorough land survey. While conducting the survey, Wilson marked the proposed elevation for each area with a white line on the telegraph poles at every other intersection as a reference for property owners, so they would know the height to which their structures needed to be raised. The survey's final conclusion was that eleven million cubic yards of fill would be needed. The advertisements for bids overcompensated and stipulated fourteen million, but the actual number used would exceed even the seventeen million suggested by the Board of Engineers.

"The Advertisement, Instructions, Specifications, and Proposal for the Grade Raising of Galveston" was fourteen pages long and included a thorough assessment of the project's numerical specifications. Within the proposal, the city was divided up into divisions A, B, C and D, and contractors were allowed to bid on all or part of the work. Advertisements were placed in every prominent technical and engineering publication in the nation and ran for sixty days.[4]

On December 7, 1903, the sealed bids were publicly opened. Surprisingly, and much to the dismay of the board, only two bids were offered.[5] However, their disappointment was soon overturned when it was realized that the winner would have been clear regardless. No matter how many bids were placed, the innovative ideas of the New York engineering firm of Goedhart & Bates would have outshone them all.

Personal histories even speculate that competitors received news of their ingenious plan ahead of the bid and schemed to upend it. The rival contractors allied and agreed not to submit their bids, presuming that if the board only received one proposition, they would call for a new round of bidding. However, their plan was foiled when a small independent contractor from Iowa, R.A. Elay of Marshaltown, arrived on the island with no knowledge of the plan. In a statement to the *Galveston Daily News*, the other contractors claimed that it was their unwillingness to accept city bonds for payment that accounted for their decision not to bid.

The plan designed by P.C. Goedhart and Lindon W. Bates was as practical as it was novel, and the men's confidence and vision was contagious. In their statement to the Grade Raising Board, they won the hearts and minds of the small island town, aided by their magnificent scheme, which solved all of the mysteries and questions that had plagued the community for years. In one fell swoop, Goedhart and Bates made the impossible possible.

In their first clever solution, the pair insisted that the fill be taken from the harbor. The firm was well-equipped with four state-of-the-art steel hopper dredges produced at their plant in Germany. The dredges were self-loading, self-propelled and self-discharging, capable of dispensing fill over long distances when docked and attached to lines of shore pipe, unlike a traditional dredge, which could only drop its contents in place. Fill from the harbor would be 80 to 90 percent water, but after it was discharged into the designated area, the water would recede and leave the silt behind. The watery consistency of the fill not only allowed it to travel long distances, but it also completely eliminated the need for scrapers and levelers due to the water's ability to uniformly mete out the silt.

One disadvantage to pulling the fill from the harbor was that the grade-raising districts were on the opposite side of town behind the seawall, and between them lay Galveston's bustling downtown and port. This was not an ideal thruway for the shore pipes, which were nearly four feet in diameter. But Goedhart & Bates had a solution for that, too.[6] The first thing they would do would be to cut a canal around the city, a waterway for the dredges that would allow them easy access to the southern parts of the city.

The path of the canal would run parallel to the seawall exactly one hundred feet behind it, and the land excavated for the canal would be used to fill in this one-hundred-foot area. This aligned with the city's desire to fill this most prominent area first so that work could begin on paving a boulevard along the beach and more immediately restore the value and attraction of the beachfront to the city.[7] The canal would also give direction to the runoff from the fill and solve the drainage problem posed by a seventeen-foot concrete wall.

It would also allow one specific part of Robert, Ripley and Noble's plan to be more efficiently executed. Their report suggested that after an embankment of two hundred feet the grade should slope dramatically downward from behind the seawall before slowly tapering off until it was level with downtown. City officials decided to reduce the embankment to one hundred feet and place the drop-off exactly where the canal was dug,

View of the grade-raising canal looking north into town from the beach. The canal was cut one hundred feet behind and parallel to the seawall. *Rosenberg Library*.

thus the proposed slope could be more accurately achieved without the inconvenience of maneuvering around houses.

The canal began at Eighth Street and the harbor and followed the curve of the original seawall down to the grade-raising boundary at Thirty-Third Street. It was three miles long, twenty feet deep and two hundred feet across with two turning basins, one at Thirteenth Street and one at the far end at Thirty-Third. All of the houses in the path of the canal or turning basins were temporarily moved at the expense of the city.

After dredging the harbor for fill, the self-loading hopper dredges of Goedhart & Bates careened down the canal, attached to a docking station near the area being elevated, and the watery fill was then released into the shore pipes. These iron pipes were laid throughout the districts in a systematic order, another arduous task. Three sizes of pipe were used, depending on the size of the dredge. The smallest measured twenty-one inches in diameter, another thirty-three inches and the largest forty-two-inch pipe came in twelve-foot lengths that each weighed over two thousand pounds.

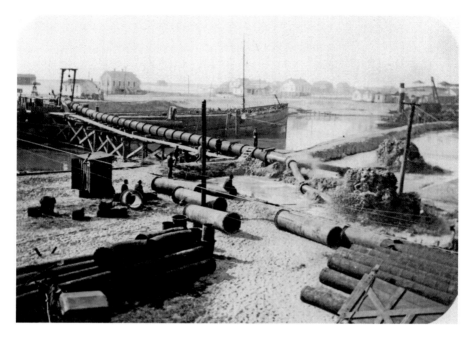

Self-loading hopper dredges took silt from the harbor to docking stations along the canal and discharged it into shore pipes. *Rosenberg Library*.

City blocks were organized into designated grade-raising districts, and levees ranging from two to ten feet high were built around each district. Property owners were responsible for both the task and expense of raising their buildings onto stilts above the height of the levee and also for dealing with the inconveniences as the watery fill swirled beneath their homes and then slowly drained, a process that was repeated countless times until the solid fill reached the desired level.[8] Some opted not to raise their houses, and instead their first floors became basements.

Boardwalks were built all across the city to facilitate pedestrians, and many of the pathways went through the front parlors of people's homes. Sometimes the drains from the levees would become blocked, other times flash flooding would leave people stranded and sometimes the water would stagnate and become a breeding ground for mosquitoes. Despite the incessant onslaught of inconvenience, the project soon lost its novelty and became merely a way of life, a challenge graciously accepted by a community willing to sacrifice its own well-being for the prize of future security and safety. Out of 2,156 houses that were raised, not one condemnation suit was filed against the city.

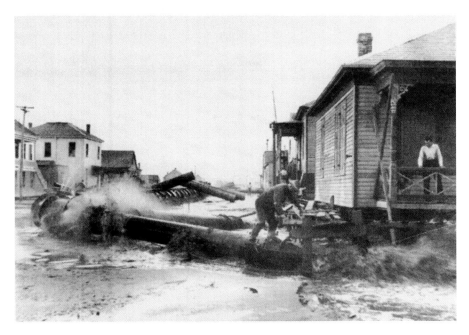

Fill being released from the shore pipe into the grade-raising district. *Rosenberg Library*.

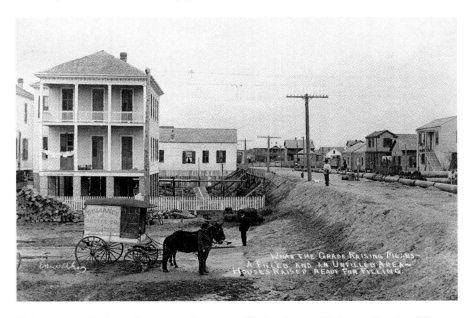

This photograph shows the contrast between a filled and an unfilled area. *Rosenberg Library*.

Homes and buildings were not the only things that had to be elevated: the entirety of the city's infrastructure had to halt and be moved or rebuilt. Sewers, water lines, telegraph lines, electricity poles, streetcar tracks, rail tracks, sidewalks, roads, streets, bushes, trees, topsoil and fences all had to be torn up and then replaced. Yet all involved used these seeming inconveniences to their advantage.

After the storm, many homeowners had taken liberty with property lines when they rebuilt, showing little regard for city boundaries of public sidewalks and alleyways. All of this was reconciled via the grade raising, and neighborhoods worked together to align their properties and fences to give the streets a sense of uniformity.

The city also used the proceedings to its benefit, rectifying drainage problems and installing underground water lines that had previously been impossible at the island's former elevation. They also installed a proper underground sewer system and underground electric power lines to eliminate poles and wires in the prominent East End.

Unfortunately, the success of the city was not experienced by the men who helped create it. The original contract began on December 11, 1903. It was completed in July 1910, and Goedhart & Bates had lost over a $250,000,[9]

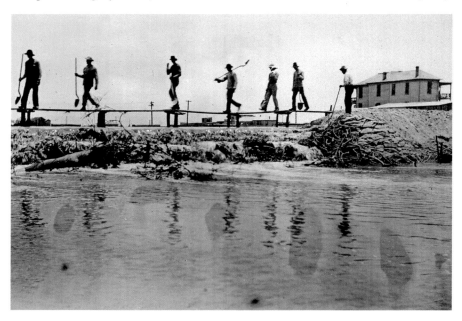

Workers walk across one of the many boardwalks erected to facilitate pedestrians while the watery fill drained from the area being raised. *Rosenberg Library.*

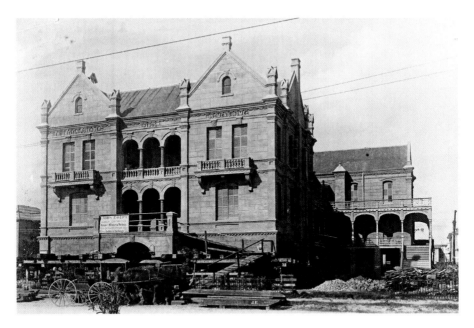

Homes and buildings were lifted on jackscrews to the appropriate height, along with all of the elements of the city's infrastructure. *Rosenberg Library*.

over $5 million by today's standards. They left Galveston disheartened and bankrupt. Their brilliance and ingenuity laid the groundwork for one of the most epic achievements in civil engineering ever accomplished, yet they were unable to finish the task and ultimately forced to surrender their stake in the endeavor. The American Dredging Company was commissioned to complete the grade raising, which at last came to a close in late 1911.

The entire undertaking, from the first hammer of the pile driver at the seawall's foundation to the day the last house was repositioned on the refilled canal path, had taken over nine years and cost the City of Galveston and its residents $6 million, a sum that today would equate to over $140 million. But what was paid in both time and money was a price entirely justified in the eyes of the islanders. The *New York Press* wrote about the city in 1903: "One has but to look at the growth of her commerce, at her private improvements; for where the city has spent millions, her citizens and the great railroads have spent tens of millions. Galveston is today a richer and busier city than before the storm." Galveston commerce had survived near annihilation; now it was following its city to new heights.

THE BOULEVARD BEGINS

1904-1910

To step into Electric Park from the softened shadows of the beach front and into the radiance of its myriad of electric lights is likened unto a vision of a fairyland. The ears are greeted by sweet strains of the band and the senses are called on to respond to the mingled shouts of the barkers, telling of their exhibitions' merits, the conglomeration of sounds, discordant, singularly but strangely fascinating when blended as a whole.
—Galveston Daily News, *September 2, 1907*[1]

The summer of 1904 was a season of change for the island of Galveston, when beach activities had little to do with sunning and swimming and more to do with forever altering the economic landscape of the prominent port city.

On July 29, the seawall as designed by the Board of Engineers was officially complete, and almost immediately, construction started on what would become the first of several extensions, authorized by the U.S. Congress in order to protect the Fort Crockett military reservation established in 1903. Finished in 1905, this first addition extended the seawall westward another 4,395 feet, or just under one mile.[2]

Meanwhile, people were wildly fascinated by this sidewalk on the sea, and the wall had become an instant attraction to both visitors and residents. Looking south from on top of the wall, they could see out over the beach and into an infinite Gulf horizon, and to the north were the sights and sounds of a dredge cutting a canal across the island. Not only did this

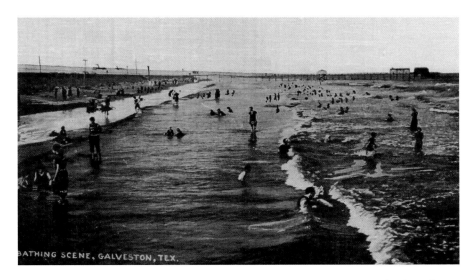

BATHING SCENE, GALVESTON, TEX.

An early view of the completed seawall before construction began along the Boulevard. *Rosenberg Library*.

two-sided panorama mark the beginning of the seven-year grade raising, the excavated fill from the canal formed the foundation that would turn a sidewalk into a sensation.

The county went quickly about paving the one-hundred-foot span behind the wall, and the early days of Seawall Boulevard were more reminiscent of a boardwalk than the motorway it is today. The first causeway to the island that accommodated cars was still a decade away from being constructed, so the Boulevard was primarily limited to foot traffic with the occasional horse and buggy. This is apparent in how the Galveston City Directory did not initially recognize it as a proper street, and the first businesses along the wall were labeled with an address of the street that bordered their northern property lines one block away from the seawall. Such was the case with one of the most notable early structures, the Galveston Auditorium, with an entrance facing the Boulevard but an address of Twenty-Seventh and Q.

The directories also reveal that commercial development on the seawall began near and around the intersection of Twenty-Fifth Street and initially moved eastward, presumably because Twenty-Fifth was a main thoroughfare that connected downtown to the beach. Visitors to Galveston would arrive via rail to the station at Twenty-Fifth Street in the commercial district and transfer to the streetcar that would take them straight across the island down Twenty-Fifth to the pedestrian drawbridge that spanned the grade raising

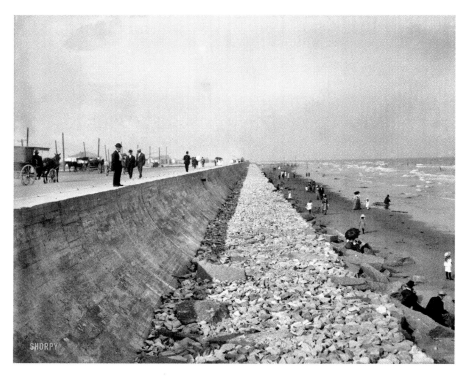

The seawall shortly after the embankment was created with the fill from the grade-raising canal. *Rosenberg Library*.

canal. The location of the Galveston Auditorium was strategically placed to draw visitors west of Twenty-Fifth Street.

The auditorium also served to appease public sentiment expressed in the *Galveston Daily News* that the city was in need of a large venue that could host conventions as well as concerts and community events. Financed by the Galveston Business League, architect George B. Stowe designed the building with a large stage and seating on the first floor and dressing rooms on the second. Completed in the spring of 1902, the Galveston Auditorium hosted the Texas Democratic convention the following summer. The next year, however, it was converted into a roller-skating rink, and in 1905, it was vacated in preparation for the grade raising in that area.[3]

That same year the first hotel sprang up at 2228 Avenue Q, the Snug Harbor Hotel, but in a very short time it would be one on a list of many waterfront accommodations. The demand for lodging was, in essence, manufactured, albeit wisely, in an effort by interested parties to claim

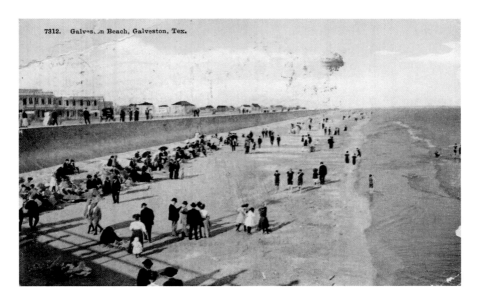

This postcard from the early 1900s shows the popularity of the seawall even before it was transformed into the "Coney Island of the South." *Rosenberg Library*.

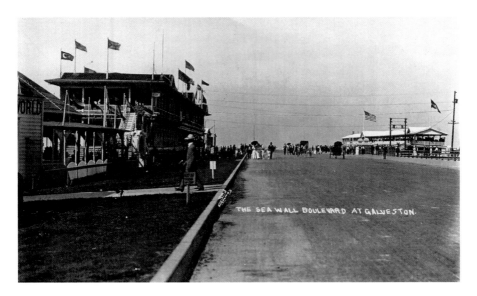

Taken at Electric Park looking east from Twenty-Third Street, this photograph reveals how the original Seawall Boulevard resembled a boardwalk more than the thoroughfare it is today. *Rosenberg Library*.

Galveston as the "Coney Island of the South" by way of creative enterprises and a whole lot of lights.

Promoters for Galveston, namely William Gardner, secretary of the Galveston Business League, argued the theory that visitors would be more likely to stay overnight if the city could entice them to stay until after dark.[4] Thus, they generated this allure by way of that cutting-edge technology called electricity, and the spectacular display called Electric Park opened in May 1906 on the block of Seawall Boulevard between Twenty-Third and Twenty-Fourth Streets. As the sun sank below the horizon its light was replaced with the glow of thousands upon thousands of incandescent bulbs.

The park was the creation of the Galveston Electric Park and Amusement Company, which was boundless in its efforts to tantalize all of the senses with a memorable, repeatable experience that would in turn benefit the city by word-of-mouth advertising and return visitors.[5] Guests were greeted by a lofty and dazzling lighted sign at the entrance, which was then made miniscule by the park's centerpiece, a huge aerial swing. The cords that attached each individual swing were studded with light bulbs that created a strobe-like effect as riders were lifted higher and higher up into the night sky.[6]

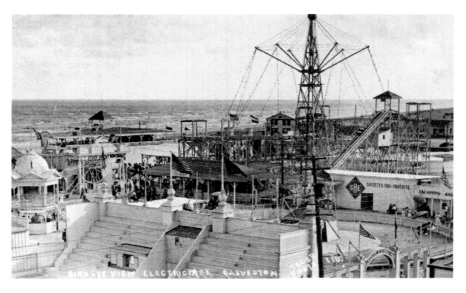

The centerpiece of Electric Park was the aerial swing. The outdoor theater sits in the foreground, and the bandstand is visible to the left. *Rosenberg Library*.

Another ride, called the Cave of Winds, took riders into the darkness as blowers sent blasts and breezes of air onto them along the way. Electric Park also had a Ferris wheel and a roller coaster called the Figure Eight, as well as shooting galleries, a live theater and an early version of a moving picture show named Hale's Tours of the World. A bandstand in the center of the park with rows of bench seating was the site of regular performances, and a short distance away was a popular gathering spot called the Crab Pavilion. The two-story open-air structure was constructed in 1905 and then incorporated into Electric Park.

The summer of 1907 boasted another amusement extravaganza in the way of Chutes Park, adding even more appeal to Galveston as an entertainment destination. The waterpark opened on May 12 on the lot adjacent to Electric Park, a product of the Seawall Amusement Company. A local distributor of Anheuser Busch named Moritz Brock presided over the company's operations, and the location was managed by a former executive of a Chutes Park in Chicago. And although it was located on the lot directly adjacent to Electric Park, it was not seen as competition. Rather, the combination of the two created for Galveston and Texas an amusement scene unrivaled in its ability to "appease the American's thirst for hazardous pastimes."[7]

Its main attraction was the Mystic Rill, a water ride that traversed over one thousand feet of man-made estuaries, traveled up an incline, went around and through the Figure Eight and then propelled the boats down a watery chute. The ride's opening was delayed due to the need for a larger motor, but finally, in July it was met with crowds that required police security.

Chutes Park also had electric fountains and cascades, a German garden with dining tables and refreshments called Happy Land and the Katzenjammer Castle, named for a popular comic strip at the time. Much of the park was dedicated to visual entertainment such as vaudeville performances and several theaters. The Illusion Theatre hosted magic shows, an early motion picture theater named the Palace of Wonders projected titles like *Arabian Dreamland* and an attraction called the City of Yesterday was replaced by the Edisonian Theater, which featured a presentation titled *An Astronomer's Dream of the Other World*.

Additional attractions were as endless as the company's creativity, with names like Giggle Alley Castle, the Palace of Mirth, the Witches' Cave, a Wedding in Fairyland, the Klondike and the New World's Scenic Railway. A 1907 advertisement in the *Galveston Daily News* boasted that Chutes Park hosted 100,000 visitors in its first seventeen weeks.

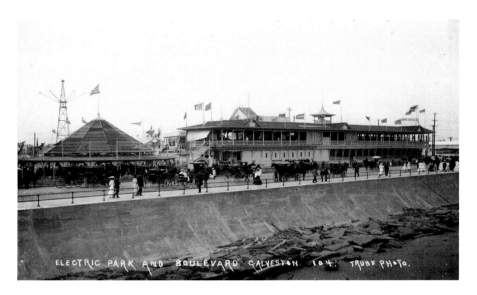

The carousel (*left*) and the Crab Pavilion were both part of Electric Park. *Rosenberg Library*.

Although a significant thunderstorm did some major damage to the parks in October 1907, both Electric Park and Chutes Park were repaired and remained operable. The Seawall Amusement Company's failure to pay its franchise tax to the city in 1908 threatened the operations of Chutes Park, but it somehow remained open despite the Board of Commissioners authorizing the company's closure. It even released plans for the next year that promised new delights and amusements such as a Venetian theater, a freak show, Whirling Dervishes and Streets of Cairo.[8]

By the summer of 1909, Seawall Boulevard included six hotels within a two-block stretch and yet a third amusement park, called Surf Park, situated at the intersection of Thirty-Second Street, while the remainder of the brick-paved boardwalk was a revolving door of restaurants, cigar shops, purveyors of seashells and souvenirs and ice cream parlors. That summer was also when the wall itself would be sharply examined for the first time.

On July 21, a Category 2 hurricane struck Galveston Island, but the seawall proved worthy of the task for which it was built. The majority of the city remained unscathed after the storm, and the only severe damage was along the Gulf side, where remnants of decimated bathhouses and fishing piers that had once stood on the beach now consumed the Boulevard. Among the structural victims claimed by the 1909 storm were Murdoch's,

Surf and Breakers bathhouses; as well as the Galveston Fishing Club pier, Bettison Pier; and the recently completed Tarpon Fishing Pier.

This widespread destruction on the beachside sparked a heated debate over allowing construction on the south side of the seawall, a debate that would prompt a procession of legislative actions over the next century. Staunch opinions from both sides argued the general expectation of the eventual demise of these insured buildings versus the negative effect their destruction had on the city in the aftermath of a storm. Although the issue would not be completely resolved for several more years, Breakers was not prevented from rebuilding within months of the storm, and Murdoch's would later follow suit.[9]

North of the wall, most of the structures on Seawall Boulevard fared relatively well in the storm of 1909, even the amusement parks. Both Electric Park and Chutes Park went relatively unscathed, and the only widespread damage was to the landscaping, which did not survive the saltwater scourge. The construction of a new exhibition hall next to Galveston Auditorium was not significantly affected, either. An aggregate of the auditorium, the Cotton Palace contained art exhibits as well as a presentation on cotton growing and manufacturing that included samples of different crops from around the

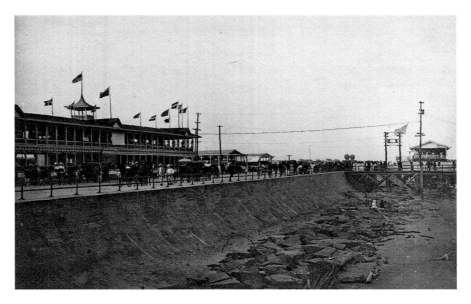

A view of the Crab Pavilion from the beach also shows where bathhouses were built on the south side of the seawall. *Rosenberg Library.*

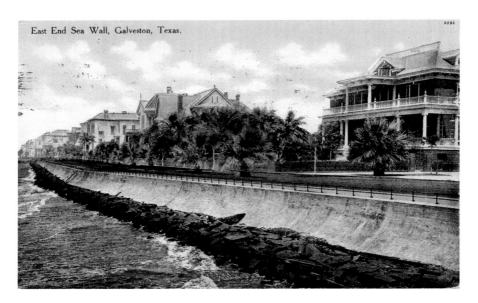

East End Sea Wall, Galveston, Texas.

This postcard of the seawall's East End depicts the lavish beachfront homes of Galveston residents in the early twentieth century. *Rosenberg Library.*

world.[10] It opened during Galveston's annual Cotton Carnival in August, less than one month after the storm.

The storm of 1909 did, however, encourage city officials to extend the embankment behind the wall from one hundred feet to two hundred feet as the Board of Engineers had initially suggested, and after the summer of 1910, both Electric and Chutes Park were demolished to ease the process of filling in the grade-raising canal and widening the Boulevard. The only remnants left of the two were from Electric Park: the aerial swing was moved to Surf Park and the carousel and Crab Pavilion were kept in place and raised with the grade.

Although Galveston's location on the Gulf of Mexico and its salubrious climate were innately a draw to out-of-town visitors from the city's inception, before the seawall and subsequent Boulevard, its status as a resort town was not one widely heralded or promoted. Today, most onlookers and historians wrongly assume that Galveston transitioned to tourism because the Great Storm of 1900 annihilated the city's prospects as a commercial port, but the city's accounting makes known a much different story.

In 1908, comparative figures reported that Galveston had advanced more rapidly than any other Gulf port in the last decade, with commercial revenues up 140 percent from 1898 and 360 percent from 1894. The total value of

exports was up $28 million from the previous year, and Galveston held the world record for the amount of cotton received in a port in one day.[11] In 1910, the city directory read, "Galveston is essentially a city of commercial pursuits," and, in noting the development along the seawall, added, "The future of the city in this respect is as bright as its commercial future....As a resort Galveston is fast taking an important place in the South."

Thus, the actuality of the situation deduces that it was not the storm of 1900 but the seawall itself that began to shift Galveston in the direction of a resort town. And it was a shift that began just in time, for the next decade would see the illustrious port city succumb to the disadvantages of its location, powerless to stop a changing economic tide.

TRADING PLACES

1911–1919

The music of the saw and the hammer, and the rattle of metal in the construction of steel buildings, is heard on every hand throughout the city, business and residential section, giving substantial indication that Galveston is but beginning her growth.
—*Galveston city directory of 1912*[1]

The historically undeniable yet often ignored rebound of Galveston's commercial pursuits after the Great Storm were due in part to the brilliant entrepreneurial minds in control of the port, but the other part was simply geography. Galveston was the proverbial gateway to the West and Midwest, areas that were booming both in agriculture and industry, and it was the closest port to the origin of a multitude of exports by several hundred miles. No established port, not even New Orleans, could compete.

But then Houston decided that it was going to try.

Between the "Bayou City" and the Gulf of Mexico was a natural waterway, the entrance to which lay only a few miles from the eastern tip of Galveston Island. It was envisioned as a shipping channel as early as 1867, though at the time the financing of such an undertaking seemed ludicrous to a small town with literal mud for streets and only a few thousand residents. But the notion became more believable as the century turned; as Houston continued its slow but steady expansion, two consequential chinks in Galveston's armor were subsequently revealed. The exponential growth of exports from the western half of the country had proven a Texas port necessary—Galveston's

proximity saved those regions upward of $30 million per year in shipping costs. However, in spite of the city's rapid recovery, the Great Storm had forever illuminated the potential peril of the island's position directly on the Gulf of Mexico. Houston was not only far enough inland to offer more protection from storms, but it was also even more convenient than Galveston, with an additional travel savings of one hundred miles per round trip.

This knowledge added momentum to the idea of the channel, but at first it appeared that Houston would do little to thwart Galveston's meteoric rise, especially considering the rapid crescendo of the city's added allure as a resort town due entirely to the seawall and its Boulevard. Even after the residents of Houston voted in 1910 to approve the dredging of the channel to a depth of twenty-five feet for a cost of $1.25 million, they seemed in no hurry to commence with the project, and Galveston's growth at the port showed no signs of waning.

On the opposite side of the island, a resort pavilion called the Casino opened in the spring of 1911 at the former location of Electric Park and Chutes Park. The Crab Pavilion and the carousel from Electric Park remained on the property, but the following July, the bandstand was relocated to Twenty-Second Street, where it remained the site of regular open-air concerts for many years.[2] Brownie Amusement Company, led by President Leon Brownie, patterned the Casino after Young's Pier in Atlantic City. A self-contained smorgasbord of entertainment, the two-story monstrosity included a pool hall, skating rink, dancing pavilion and shooting gallery on the first floor. The second level housed a restaurant and a large dance hall where full orchestras would serenade partygoers. Above the dance hall was a roof garden that became a sought-after social setting. Guests could lounge or eat dinner with an unadulterated view of the cityscape to the north and a dark Gulf lined with lighted ships to the south.[3]

The Casino was located on the west side of the Twenty-First Street intersection, diagonally across from the newly resurrected Murdoch's Bathhouse, which reopened that same spring for the first time since the 1909 hurricane. Inside Murdoch's was a new restaurant operated by a recent transplant to the island named S.J. Gaido. Immediately praised for the quality of its fare, Gaido's would go on to become a Galveston institution.

That same year, the exhaustive grade raising at last came to a close. The colossal achievement was grandly celebrated by the construction of a resplendent five-story hotel. Situated at the corner of Twenty-First Street and Seawall Boulevard, the idea for the Hotel Galvez was nurtured by a group of prominent Galveston businessmen who wanted to both celebrate

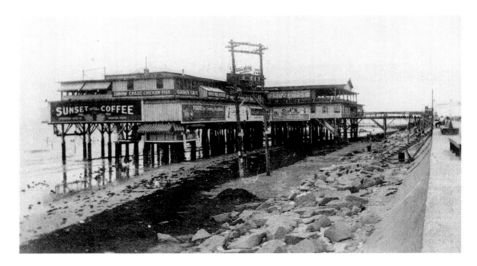

Murdoch's at Twenty-Third Street was the original location of Gaido's Seafood Restaurant. *Rosenberg Library*.

the completion of the grade raising and present to the world an extravagant symbol of the island community's resilience and commitment to its future. Upon its June 1911 opening, the Hotel Galvez was dubbed the "Queen of the Gulf." The regal structure and elegant grounds singlehandedly elevated the notability and status of Galveston's beachfront, and the Spanish Revival–style design instantly became an icon of the seawall.

At the close of the 1911 summer season, Seawall Boulevard was officially dedicated as a proper thoroughfare and opened to vehicular traffic on September 9, although Galveston residents who owned automobiles had been driving the stretch of road since it was widened the year prior. In honor of the event, the city held a parade of vehicles led by Texas governor Oscar Colquitt. It traveled west to Thirty-Ninth Street and then back east, ending at the bandstand. There Governor Colquitt made a lofty speech regaling Galveston's accomplishments.[4]

When the original causeway opened on May 25, 1912, allowing access to automobiles from the mainland for the first time ever, Galveston once again stood at the brink of invincibility as its popularity reached a fever pitch. Seawall Boulevard was practically a parking lot, completely inundated with traffic jams that were often exacerbated by thousands of pedestrians walking along and across it.

Later that year, on the evening of September 28, 1912, the seawall received a sparkling embellishment in the form of a sixty-foot-tall electric

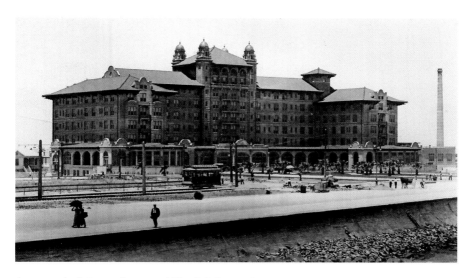

A postcard of the newly opened Hotel Galvez at Twenty-First Street. The lot to the left would be the future site of Joyland Park. *Rosenberg Library*.

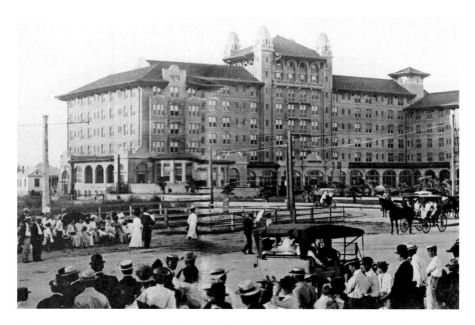

The juxtaposition of carriages and automobiles on the seawall demonstrated early on the Boulevard's ability to keep pace with technology and trends. *Rosenberg Library*.

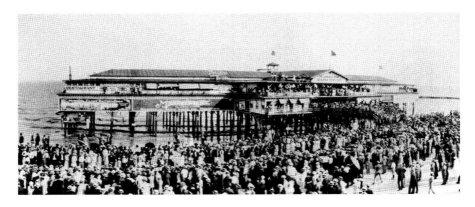

A photo of Murdoch's gives a glimpse of the massive crowds that would flock to the seawall. *Rosenberg Library*.

sign installed at the foot of Twenty-Fifth Street. The sign was part of a collaboration between Brush Electric Company and the Galveston Commercial Association to make Galveston the "best lighted city in the United States."[5] Months prior to its official lighting, Brush announced to the *Galveston Daily News* its plans "to tender the people of Galveston something of its art and product that will contribute to the general welfare of Galveston,"[6] but it was also a form of advertising and an added way to increase the appeal of the Boulevard as a nighttime and overnight destination.

The sign was designed by Valentine Electric Sign Company in Atlantic City, and the slogan was selected from a public contest. A concrete foundation braced the towering steel framework, and three thousand tungsten lights spelled out "Galveston the Treasure Island of America—Port and Playground—Growing Greater Grander." A blazing symbol of the city's ambition, it was lit for the first time by Mayor Lewis Fisher to the delight of hundreds of onlookers.[7]

This unabashed announcement of the city's intention to remain a force as a center of commerce and tourism was firmly backed by numbers. The combined imports and exports of the Port of Galveston for 1912 totaled nearly $300 million—second in the nation behind only New York and $37 million more than New Orleans—and a town that just a decade earlier had a mere spattering of overnight accommodations now boasted thirty-six hotels. But in one day, everything changed.

On November 10, 1914, President Woodrow Wilson declared the Houston Ship Channel open for commerce. Now instead of turning left into Galveston's natural harbor, the huge international steamers full of

worldwide wares merely waved and cruised right on by into the channel and further on into the newly designated Port of Houston.

Suddenly, Galveston's frenzied wharf grew quiet and lethargic. Businesses began to relocate, skilled laborers moved where their talents were needed and they took their families with them. The prefaces to subsequent city directories, where once the entirety of fifteen pages had been used to expound upon Galveston's commercial and financial pursuits, became mere history lessons that chronicled, year by year, a steady decline in the resident population.

Adding insult to injury, another hurricane struck in 1915. The Galvez and the lighted sign managed to escape catastrophe, but the Casino, the Crab Pavilion and the carousel suffered heavy damage, as did Murdoch's and Breakers, which were annihilated once again. However, despite a storm surge that measured the same level as that of the 1900 storm, only eleven lives were lost in the city, while the unprotected areas saw casualties up to five times that number.[8] Thus Galveston's faith in its concrete savior was renewed, and soon the haze of the Houstonian-induced stupor began to lift. The islanders who remained simply decided to play the cards as they were dealt, which meant going all in on the seawall.

Following the storm, 1915 became a record year for construction.[9] Most of it was along Seawall Boulevard, demonstrating Galveston's willingness and determination to embrace and fully exploit its new identity. The wreckage from the buildings along the beach reintroduced the argument surrounding construction south of the wall, but in January 1916, a resolution casually dubbed the "bathhouse amendment" was defeated by Galveston voters and Murdoch's and others were given the green light to rebuild.[10]

Shortly thereafter, the Crab Pavilion and the carousel were deemed irreparable and torn down, but the Casino was fully restored and reopened. However, it would soon pale in comparison to the new Crystal Palace situated just to the west, the most outrageous of any seawall construction thus accomplished. Over seven thousand people attended the grand opening of the three-story complex, which easily dwarfed the massive Casino not only in size but also in offerings. Its most exhilarating inclusion was a 50-foot-wide, 140-foot-long swimming pool on the first floor, bordered by poolside seating for seven hundred people. Suspended above fresh saltwater pumped in from the Gulf were gymnastics rings and two diving platforms that rose 50 and 75 feet in the air.

Incorporated into the upper two floors were eight hundred dressing rooms for changing in and out of beach attire, a photo gallery, a shooting gallery, a roof garden, an open-air amphitheater, a bowling alley, a café, a space

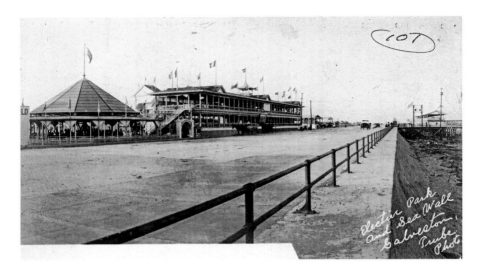

The Crab Pavilion and the carousel were heavily damaged in the 1915 hurricane and demolished the next year. *Rosenberg Library.*

The Crystal Palace at Twenty-Third and Seawall. *Rosenberg Library.*

for live music and a nine-thousand-square-foot dance floor. But perhaps the biggest spectacle of the Crystal Palace was the elevated promenade, which stretched sixty-eight feet from the second-floor balcony over to the beach, sixteen feet above Seawall Boulevard.[11]

The hurricane also prompted additional construction for the seawall itself. Back in 1913, the Board of Engineers recommended a second extension of the wall, this time eastward to protect the Fort San Jacinto military installation. No action was taken at the time, but the damage from the storm helped to convince Congress to finally authorize its construction in 1916. They were also persuaded by wealthy Galveston resident Maco Stewart, who owned the majority of the East End Flats—the low-lying area between

The elevated walkway connecting Crystal Palace to the beach was sixty-eight feet long and sixteen feet high. *Rosenberg Library*.

the Sixth Street wall and Fort San Jacinto—which had been nothing but a trash dump and breeding ground for mosquitoes since 1909. An eastward extension would not only protect his land but also create an embankment against which it could be filled and transformed into viable property. Stewart offered to transfer six hundred acres of the flats to the federal government to expand the fort; the deed was signed on May 11, 1917.[12]

In 1918, work began on this far eastern portion of the seawall. The extension began at Sixth Street, where the original wall curved north toward the harbor and created a fork in the wall that ran directly eastward for nearly two miles past the East End Flats to Fort San Jacinto. Construction was delayed when a nominal hurricane struck the coast in 1919 and damaged the construction sites, extending the project another two years.

As the decade came to a close and construction resumed on the wall, the Boulevard welcomed yet another thrilling addition to Galveston's amalgamation of amusements. Joyland Park was operated by the Galveston Playhouse Corporation, owned by the two men who also managed Crystal Palace, J.R. Stratford and R.S. Lindamood. Sandwiched between the Galvez and the Crystal Palace, Joyland Park encompassed the entire Twenty-First Street block along the seawall. The first phase of the park included the incorporation of the bandstand since moved from Electric Park, a theater called the Orpheum and a Ferris wheel. Later, the theater was converted into the Garden of Tokio, and an airplane swing was installed along with an arena called the Great American Racing Derby.[13]

Many of the commercial developments along Seawall Boulevard throughout this particular decade would prove themselves ephemeral, subject to passing trends and as fleeting as fashionable fads, all too often a marionette

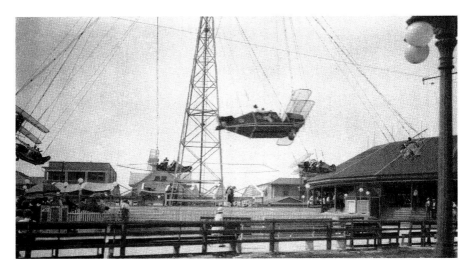

The Great American Racing Derby at Joyland Park opened on May 27, 1920. *Rosenberg Library*.

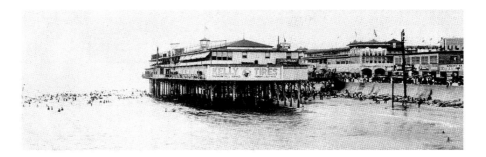

Murdoch's and Crystal Palace, a view from the water. *Rosenberg Library*.

in the hands of Mother Nature. But this era also marked the dawn of four familial and institutional legacies that are still today an integral part of the Galveston Seawall. Hotel Galvez, Gaido's Seafood Restaurant and Murdoch's Bathhouse all remain; the latter two remain in the same family.

The fourth name on that list did not belong to a particular business, rather to a pair of brothers from Italy. They began their careers in Galveston as barbers at a local shop called Cappadona's but, within a year, made their way to the illustrious seawall, one with a chair inside Murdoch's Bathhouse and the other with his inside the Hotel Galvez.[14] In 1920, the United States would make Prohibition the law of the land, but fortunately for Galveston, Sam and Rose Maceo would learn quickly the art of making resource from restriction.

CRASHING WAVES AND ROARING TWENTIES

1920-1929

It became the sin city of the Gulf Coast, based upon a triad of prostitution, gambling, and drinking...[T]hey flourished in Galveston under the benign eye of the local authorities.
—*David G. McComb*[1]

January 17, 1920, marked the official inauguration of Prohibition in the United States. An attempt to assuage so-called societal ills, the Eighteenth Amendment sent into effect a nationwide constitutional ban on the sale of alcohol as well as its production and importation. Galveston County had actually been dry since 1918, when it endorsed the proposed amendment even before it was ratified.

On the seawall, Sam and Rose Maceo's new locations put them in the thick of the territory of the Beach Gang, whose main operation was bootlegging. The Maceos and gang leaders Dutch Voight and Ollie Quinn were fast friends, and soon customers at the barbershop were privy to gifts of cheap wine that would usually result in the purchase of a bottle. Conveniently, the bottles fit perfectly into a hollowed-out loaf of French bread.[2] As the government and law enforcement became more intent on eradicating alcohol, the people became more interested in acquiring it. Gradually, the Maceos became more serious bootleggers, and their continued foray into an economy of vice would propel Galveston into an economic boon that would last nigh on four decades.

Sam Maceo seemed to discover early on that the success of illegitimate business in Galveston ironically hinged on the city's legitimate reputation. He founded the Galveston Beach Association and utilized the talents of another ambitious young man by the name of William E. Roe.[3] In 1920, Roe began working tirelessly on behalf of the city and the Galveston Beach Association to expand the allure of the seawall and Galveston as a prestigious resort destination. He concocted a marketing plan that would prominently earmark the beginning of beach and swimming season with an official opening day called Aquatic Day. It launched on May 23, 1920, and the pinnacle of the festivities was a pageant called the Bathing Girl Revue.

Initially, the Bathing Girl Revue was more of a costume contest than a beauty contest, an attempt to raise the profile of the seawall by way of high fashion and "part of the effort to make Galveston a summer resort deluxe."[4] In their assessment of Galveston's summer season, the Beach Association proposed that "color and style were the only thing lacking to spice the natural attraction of the finest surf bathing on the Texas coast,"[5] and the revue would diverge "from one-piece suits and encourage fair bathers hereabouts to adopt the fancy and more modest attire effected [*sic*] by frequenters of Venice, Newport, Atlantic City, and other fashionable resorts."[6] In addition to one grand prize, awards would be given for the most elaborate, most original, most artistic, most becoming and most unique costumes.

Although turnout for contestants was expected to be much higher than the seventeen who entered the first year, the Bathing Girl Revue drew a crowd from all over Texas and an estimated twenty thousand people attended, a number thought by many to be the all-time high for a single event.[7] The *Galveston Daily News* reported that the number of people on the Boulevard "increased until a solid mass of humanity banked bathing piers, flanked seawall, and pushed out and crowded along the Boulevard."[8] They lined up to watch the procession of bathing beauties, who started at the Crystal Palace, then walked along a makeshift boardwalk to the East End Fishing Pier and then turned back again.

The contestants then made their way up to the roof garden atop the Crystal Palace, where the costumes were judged and prizes of high-end jewelry were awarded. Galveston resident Reba Dick took home the grand prize of a $250 diamond ring "for general attractiveness, originality, and becomingness."[9] Following the contest, the competing ladies rode in a vehicle parade down the seawall past throngs of people lining the Boulevard.

The first year of the new decade also brought the demolition of Galveston Auditorium. Its previous owners, the Galveston Commercial Association,

Contestants from the Third Annual Bathing Girl Revue in 1922. *Rosenberg Library*.

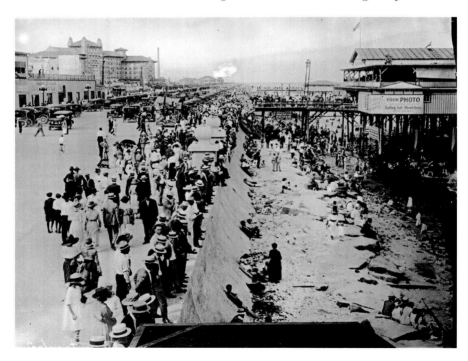

Crowds line Seawall Boulevard to catch a glimpse of the parade, circa 1923. *Rosenberg Library*.

deeded the building and the surrounding property to the City of Galveston in 1914. The land was used to create Menard Park, intended to be a public respite where visitors could escape the rowdiness of the beachfront. With the auditorium out of the way, trees were planted and a band shell was added for concerts. The park also included benches, fountains, a sprawling lawn and a playground.[10]

In March 1921, the first eastward extension of the seawall toward Fort San Jacinto was finally completed—three years from its inception. It added an additional 10,300 feet to the length of the concrete barrier and was immediately followed by petitions to Congress to extend it even farther.[11] The request was authorized to extend the wall to protect the entirety of the Fort San Jacinto Reservation all the way to the South Jetty.[12]

Meanwhile, another part of the seawall was going vertical, with the construction of a roller coaster called Mountain Speedway well underway. Ingersoll Amusement Company built roller coasters all over the country, and Galveston's opened in the summer of 1921 along the block of Twenty-Second Street behind Crystal Palace. Advertisements in the *Galveston Daily News* described the monstrous roller coaster as "Deep Canyons of Real Joy," and it was touted to provide "all the thrills of ice skating, skiing, or high diving."[13]

By 1923, around the same time that the Brush Electric sign at Twenty-Fifth Street yielded to corrosion and had to be taken down, the Maceo brothers garnered the funding and business expertise to acquire a piece of property over the water on the south side of the seawall at Twenty-First Street. Previously a fishing pier, a Mexican restaurant and then an outdoor park, Sam and Rose's purchase of the pier led to the opening of their first restaurant venture on the site: Chop Suey. Three years later, in 1926, the restaurant metamorphosed into a dancing and dining club called the Grotto, and the extracurricular activities that it provided marked the brothers' entrance into the world of gambling and gaming.[14] The presence of the Grotto and its popularity sparked a wave of growth that manifested both structurally and economically, and the mid- to late 1920s were an apex of development on the seawall.

Construction of the second extension of the seawall toward Fort San Jacinto was still in progress when work began on paving the length of the eastward leg to create East Seawall Boulevard. This new portion of road would travel from the fork at Sixth Street all the way to the beach on the far side of the island. It was dedicated and opened with much celebration on July 4, 1925, and fortunately for Maco Stewart, the development of the

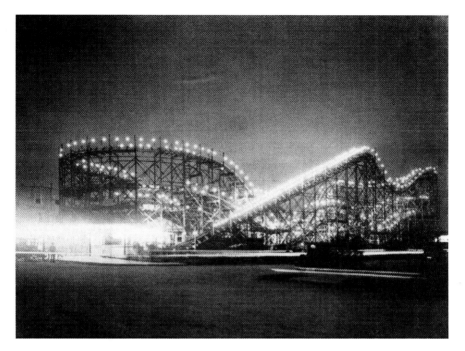

A nighttime view of the Mountain Speedway roller coaster. *Rosenberg Library*.

A 1920s postcard advertising the seawall's newest sensation. *Rosenberg Library*.

roadway was an integral part of changing public perception toward the East End Flats. Since they were now located directly behind the Boulevard, an area that had been one of filth and pestilence now seemed viable property suitable for development.[15] Immediately following the second extension's completion in 1926, a westward extension that measured 2,800 feet was initiated by Galveston County and completed one year later.

Six years into his genius marketing plan, William Roe came up with another idea, one that would garner worldwide attention and influence pop culture forever. Aquatic Day had been a big hit every year, but the name was changed to the more fun-inducing "Splash Day." The Bathing Girl Revue became the seawall's ultimate draw, larger than anyone had anticipated, and every year it gained in popularity, with an increase in both contestants and attendance. Year after year, it gained in popularity, and for the seventh annual competition in 1926, Roe devised a plan to turn it into an international pageant. Dubbed the First Annual International Pageant of Pulchritude, Roe invited beauties from all over the world to compete on the roof of the Crystal Palace.

No longer under the guise of a costume contest, the International Pageant was now officially a beauty pageant. Contestants would vie for the title of "Beauty Queen of the Universe," with three rounds of competition: sports costume, bathing costume and evening costume. By 1929, representatives from eleven countries traveled to Galveston to compete for an astounding $2,000 prize, coming all the way from England, France, Germany, Austria, Luxembourg, Spain, Romania, Cuba, Belgium and Iceland. The event became a wild success, and attendance grew tenfold, with an estimated 250,000 visitors arriving to see the pageant.[16] They swarmed around the

boulevard and watched as the girls paraded in vehicles down the seaside thoroughfare, standing on wooden platforms built atop convertibles, secured only by holding on to a rope tied to the moving vehicle below.[17]

As the demand for accommodations on the seawall skyrocketed, so did the value of real estate along the beachfront. Joyland Park succumbed to the demand and was sold in 1928 to developers who planned to build an eleven-story resort hotel with over four hundred rooms. Every aspect of the park was dismantled or demolished to make way for the new structure, except for the Garden of Tokio, an open-air dance pavilion that was added to the park in 1921.[18]

On the lot to the east, the highly anticipated million-dollar Buccaneer Hotel opened on May 1, 1929. Designed by architect Andrew Frasier and financed by the Moody family, one of Galveston's most prominent, the eleven-story, 440-room mammoth was the second-tallest building on the island. The Buccaneer included a dining hall, a ballroom, a parking garage, an indoor putting green, recreation rooms and a sun parlor, and it was outfitted with all of the most modern luxuries—pure distilled ice water in every room, ceiling fans, a laundry chute and rooftop sunbathing.[19]

The outrageous influx of visitors to the Galveston Seawall every spring and summer season was also spurred on by the rising popularity and accessibility of automobiles in the 1920s, and license plates at the time, numbered by city, revealed that people were flocking to the island from all over the state. Of course, this proved troublesome for a motorway with zero traffic control—it was never before needed—and now Seawall Boulevard was incessantly congested.[20] Attempts were made to alleviate the situation, but residents and city officials seemed forever at odds with one another on a solution.

The Third International Pageant of Pulchritude, 1928. *Rosenberg Library*.

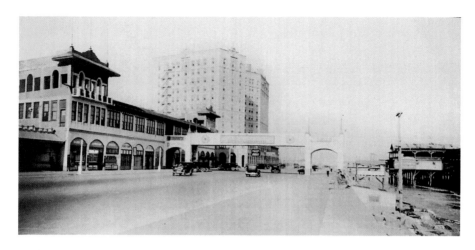

Looking east down the seawall toward Crystal Palace with the Buccaneer Hotel in the background. *Rosenberg Library*.

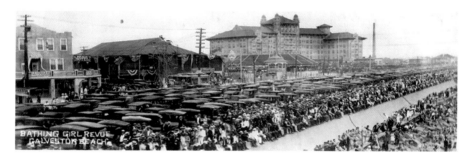

This 1925 photograph reveals the scope of the traffic congestion on the Boulevard. *Rosenberg Library*.

An organization was formed to represent local motorists called the Galveston Automobile Protective Association. When city authorities installed a traffic tower with a signal in the middle of the Twenty-Third Street intersection in 1924, they deemed it a traffic hazard and demanded that it be taken down. Although at first the commissioner of fire and police ignored their protestations, the tower was eventually removed.[21]

Another tactic utilized to manipulate traffic flow was diversion. On one particular day in August 1929, the boulevard was purposely closed between Twenty-Second and Twenty-Fifth Streets, and vehicles were forced to detour down Avenue Q. This prompted the idea of establishing an "amusement district" along the corridor to eliminate the "clamor of automobile horns,

the odor of exhaust fumes, and the very hazardous adventure of crossing from one side of the Boulevard to the other." Even though the idea was supported by the owner of Crystal Palace and the president of the Galveston Beach Association, it never culminated into reality.[22]

Aside from the ruckus of tourists, traffic, beachgoers and bootleggers, the city was also entrenched in deciding how to proceed with the East End Flats. Maco Stewart advanced the notion that it was the city's responsibility to eliminate the "mosquito farm" on the east end of the island and strengthened his case with talk of the potential negative repercussions of its proximity to John Sealy Hospital. In May 1929, residents voted to approve a $75,000 bond proposal that would result in the first major filling since the grade raising. The measure was vehemently and vocally opposed, however, and legal conflict arose that would delay the release of project funds for two years.[23]

As 1929 drew to a close, the nation was again struck with a crippling blow to its societal norms, although the crash of the stock market on October 29, 1929, was undeniably felt more so than the ban of alcohol. In a single day known as "Black Tuesday," the world was violently ushered into the Great Depression. But as unemployment skyrocketed and income plummeted throughout the country, the Maceos were just getting started, and their enigmatic, yet palpable approach to protecting the city's economy would provide a much-needed buffer to the woes of the outside world.

THE ORIGINAL SIN CITY

1930s

*The Maceos dominated politics…allied with bankers, and employed much of the
citizenry.…Every business prospered, even during the Great Depression.*
—*Robert M. Utley*[1]

Tremors from the crash of the U.S. stock market were felt all over the world,
and few were left unscathed by the Great Depression. Between 1929
and 1932, the worldwide gross domestic product dropped 15 percent, and
international trade was severed in half. But Galveston proved itself somewhat
impervious to economic collapse and suffered little collateral damage. Not
one bank on the island failed in the 1930s during the Depression—what
was lost by way of a diminished expendable income for beach vacations was
gained through Galveston's provision of an escape from reality and the hope
of a lucky hand.

In fact, the biggest concern on the minds of islanders in 1930 was the
drama surrounding the filling of the East End Flats. The area between
the original eastern border of the seawall (currently Sixth Street) and the
eastward extension down the coastline was privately owned, but taxpayers
had been expected to put up the funds for its development. Via popular vote
the year prior, Galveston taxpayers did approve the bonds needed for the first
358,000 cubic yards of fill to partially raise the grade of the swamp in the
interest of public health, but litigation against the bond decision galvanized
public opinion. Contention continued to mount against the landowners,
namely Maco Stewart, who all but demanded taxpayer assistance. The

An aerial view of the seawall taken in 1931 by the Thirteenth Attack Squadron, an aviation unit of the former U.S. Army Air Corps stationed at Fort Crockett. *Rosenberg Library*.

litigation was ultimately unsuccessful, but it did delay the release of the project funds for two years, which were finally handed over in early 1931. Soon after, the filling began, and by October, the Gulf Coast Dredging Company had completed a fourteen-foot elevation of the East End Flats.[2] Much more filling was needed, but the legal protestations brought to light a perspective that permanently undermined public support for the task. Henceforth, the voting population would battle city officials for nearly two decades, stubbornly unwilling to foot the bill for additional fill.

Recreationally, the seawall did at first appear susceptible to the crippled state of the economy; the million-dollar hotel slated for the former site of Joyland Park acceded to the Depression and was never built. The Tokio Dance Pavilion was left standing during the demolition of the park, and under new ownership, it was remodeled and reopened in 1930. The open-air ballroom was lit by the sparkling luminescence of crystal chandeliers and the colorful glow of hundreds of paper lanterns. Exotic flowers adorned the pavilion, and the perimeter was lined with retractable canvas shades that could be pulled down during rainy evenings. Tokio Dance Pavilion was open continuously from the start of springtime through the summer months; dances were held on the

weekends in the spring and then every night in June, July and August[3] until 1939, when it was converted to a skating rink.[4]

The highly attended Splash Day also fell victim to the aftermath of the Great Depression. It ceased in 1932 and with it went the International Pageant of Pulchritude. From that point on, beauty competitions became a statewide affair, but the brilliance of William Roe's concept would prove timeless in the end. His promenade of beauty down the shores of the Gulf Island would follow a trail of history and eventually become the inspiration for the modern Miss Universe pageant.

Later that summer, on August 14, 1932, a category 4 hurricane struck the small town of Freeport located about forty-five miles down the coast from Galveston. Along this moderate stretch of coast between the direct hit and the island with no added protection forty lives were lost, and the total damage surmounted nearly $8 million. But the seawall stood stoically, and the city of Galveston reported zero casualties and sustained only minor damage.[5]

Nonetheless, the destruction did prove enough to renew the Maceos' interest in reopening their stake on Seawall Boulevard. The brothers' Gulf-side club, the Grotto, was raided and forcibly closed down by the Texas Rangers in 1928 due to gaming violations and alcohol consumption, and the building at Twenty-First Street and Seawall Boulevard remained ominously vacant, on unforetold standby with Splash Day and unbuilt hotels. The Maceo empire itself was by no means destitute; the loss of the Grotto was voluminously cushioned by the brothers' Hollywood Dinner Club, which generously provided all of the same "accommodations." Its location on the western outskirts of town at Sixty-First Street was among several other gaming and liquor joints—although the state had taken an interest in abolishing Galveston's vice economy, city and county officials were more than willing

Fifth International Pageant of Pulchritude and Eleven[?] Galveston, Texas, Augus[?]

to overlook these indiscretions given the infusion of cash they provided at a time when the rest of the country was floundering and impoverished.

By the time of the 1932 hurricane, Sam and Rose had assumed almost complete control of Galveston's underground undulations of booze and gambling, as any previous rivalries had either been shut down, bought out, forced to leave town or arrested.[6] Rose's strong arm and Sam's suave demeanor were the perfect combination, and both of the men possessed a sincere interest in the welfare of Galveston. Sam's irresistible charm and smooth talking were responsible for much of the cooperation from local and even state officials, but he also won over the residential population with his philanthropic and fatherly approach to his fellow Galvestonians, such as establishing his own group of lawmen and personally preventing locals from gambling beyond their means. This reverent faith in the Maceo family formed a solidarity in the community while Galveston's brazen disregard for the law engendered a feeling of invincibility. The island was by no means the only place in the country with liquor, gambling and prostitution, but it was one of the few that made very little effort to hide it. Following Sam's lead, Galveston also handled its illicit reputation with grace and style, providing openness around the industries as well as a level of guardedness fit for celebrities. The big-name performers that Sam was able to lure to Hollywood Dinner Club not only drew huge crowds to the clubs, but they also offered scenery at the local hotels that instantly elevated the echelon of clientele visiting the city. With the police in their pocket and the city on their side, the Maceos had developed a formula for success, and the time had come to return it to the seawall.

The storm made repairs to the Grotto property inevitable; thus, with established enterprises and a firm confidence, the Maceos rolled their own proverbial dice. They spared no time or expense in the reclamation of their

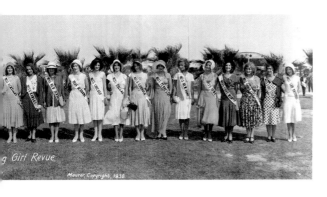

In 1931, the fifth and final International Pageant of Pulchritude was held in Galveston. *Rosenberg Library*.

seawall business and quickly executed a splendid remodel of the building's interior with Asian-inspired décor and the construction of a new pier that extended two hundred feet over the Gulf of Mexico. It was called the Sui Jen Café, and it opened in late 1932. Upon completion, it was hailed as one of the most beautiful establishments in the nation and further confirmed the Maceos reputation as the ultimate hosts.[7] They provided elegant atmospheres, world-renowned entertainment and unlimited vice with the added benefit of discretion, all of which drew spectators and participants from all across the United States. In 1933, Prohibition was lifted, although liquor by the drink remained illegal; nevertheless, the bootlegging would continue in order to avoid regulation and taxes, as would proscribed gambling and prostitution.

Bolstered financially by this foray into the forbidden arts, the municipalities worked to perpetuate the legitimate side of the city for the symbiotic benefit of both the Maceos and the local government. If Maceo business was good, everyone's business was good; thus, a most convincing smokescreen was devised. Galveston commissioners approved the use of city funds to launch a nationwide advertising campaign regaling the family-friendly attractions, superior hotels, temperate beaches and good, clean fun to be found on the island. They also managed to attract a large number of conventions, and as many as seventy-five organizations held meetings in Galveston every year.[8]

Further bolstering Galveston's nationwide acclaim was the 1933 release of the song "My Galveston Gal," written by one of the members of Phil Harris's band. The tune was a regular on the playlist at Harris's radio station, and the attention it garnered soon established the island city as a highly sought-after year-round entertainment destination.[9] New construction erupted all over town but especially on the seawall, where proprietors sought to capitalize on the fame of Galveston and the Sui Jen. Business listings at the time read like a kaleidoscope of amusements that changed every year, featuring novelties such as Japanese Rolling Ball, a penny arcade, the Great American Racing Derby, the Whoopee House, the Choo Choo Train, Boulevard Bingo and the Crazy House. The boulevard also boasted several "sportlands" full of athletic amusements, skating rinks and shooting galleries.[10]

More attractions and more people meant more automobiles, and the woes induced by the traffic problem on the seawall were a perpetual source of conversation among city officials and residents. In 1936, an advisory committee to the Board of Commissioners called the Galveston Coordination Committee was assigned to the task of revisiting the "amusement district" concept that had emerged several years prior when a few blocks of the

Left: The Maceos' Sui Jen Café was considered one of the most beautiful establishments in the country. *Rosenberg Library*.

Below: A 1993 map of Galveston Island. *Rosenberg Library*.

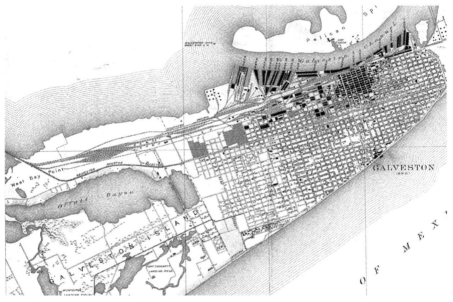

boulevard were experimentally closed to vehicular traffic. A special subcommittee was formed to ferret out a solution for seawall traffic, but any efforts were fruitless.[11]

Another facet of the traffic debate involved parking along the south side of the wall. Angled parking was argued by many to be an impediment to moving traffic, but parallel parking would reduce the number of available spaces. The city also considered installing parking meters for the first time in 1936, an idea quickly squashed by local business owners. During the summer of 1939, parallel parking was initiated on a trial basis with a two-hour time limit from noon to midnight, but a mere two months later, it returned to the angled system.[12]

As the decade drew to a close and the United States began its slow ascent back into the folds of financial prosperity, Galveston continued to thrive and make firm its foothold as a national interest. At the recommendation of the Beach Erosion Board and the Army Corps of Engineers, Congress authorized the construction of a groin system to reinforce the toe of the seawall and prevent erosion. From 1936 to 1939, fourteen 500-foot groins were constructed at 1,500-foot intervals along the length of the wall.[13]

Of course, the rise of Galveston in name and notoriety during the 1930s and its ability to survive with grandeur the greatest economic collapse the world has ever seen was due almost entirely to the illicit but ingenious entrepreneurial endeavors of Sam and Rose Maceo. Buoyed by their success, business owners and residents readily embraced Galveston's identity. Braced by this unabashed acceptance, the city became known as the "Free State of Galveston." City directories from the era in no overt way acknowledge the full story behind Galveston's allure at the time, but they cannot help but reflect the demand for the city's highly sought-after escapades. They make known all of the frivolous beachfront businesses that were subject to the latest fads and engaged in all the comings and goings of a carousel, while the Sui Jen Café remained steadfast. They list a growing number of hotels year after year and a steady increase in the city's population, but never is there any reference to any sort of illicit activity. The directories do go so far as to mention that "the city has the reputation of having a most contented population."[14] This at a time when the rest of the country faced 25 percent unemployment and stood in bread lines. Contented, indeed.

WAR AND PIERS

1940s

[They had] gambling to support the high cost of entertainment. Or high priced
entertainment to support the profits of gambling. Opinions vary.
—Galveston Daily News[1]

The dawn of this new decade carried with it the momentum of the
one previous, as Galveston's ever-expanding population continued its
vicarious love affair with the vices of its frequent visitors and all of the
prosperity they afforded. The fog of economic depression had at last lifted
from the rest of the country, but since it had not greatly affected the island
in the first place, the city merely continued along its upward trend of
growth and expansion as its fan base blossomed. The nation was content to
breathe a sigh of relief at the return to normalcy, but the seawall verifiably
boomed—and along with it Galveston's population. The 1940 census
registered 60,862 residents,[2] more than double the population of the city
before the 1900 storm.[3]

The Sui Jen remained a priority destination, and the hotel industry
flourished by way of the gamblers and thrill-seekers. Massive developments
along the seawall such as the Buccaneer Hotel were unabashed proclamations
of Galveston's adventurous reputation, and in 1940, they were joined by the
Jack Tar. Another project of the Moody family, the two lots for the expansive
motor court were purchased the year prior. Located on the filled area east of
Sixth Street (behind the seawall's eastward extension), a modest eighty-three
rooms enjoyed ample space and views of the Gulf of Mexico. The units

were staggered on three rows and along the sides of the northeast corner of the lot, and a winding driveway ran throughout the complex. At the front of the property were the main office as well as a gas station and a drive-in restaurant that were open to the public.[4]

Meanwhile, Galveston city officials remained stubbornly persistent in their attempt to persuade residents to pick up the tab for the raising of the East End Flats. In May 1941, ten years after the initial filling of the swamp land at the far eastern end of the seawall, yet another bond proposal was put to the population for a vote. This time, the city wanted $350,000, and Mayor Brantly Harris (1939–42) did his best to sell voters on the fact that it would allow eastward expansion and the ability to develop new neighborhoods. He argued that the benefits of the filling would be advantageous to the entire city, not just the private landowners. Other supporters agreed and maintained that the added property taxes from the residential lots created by the fill would be a welcome addition to the city's tax roll. The proposal was rejected anyway, but the landowners and city officials were not yet ready to shelve the referendum.[5]

In the summer of 1941, the city commissioners once again made headlines when they revived the notion of installing parking meters along the seawall. They took their case to Galveston County, the wall's technical owners, but

The new Jack Tar Motor Court was a modern concept with eighty-three rooms, a restaurant and a gas station. *Rosenberg Library*.

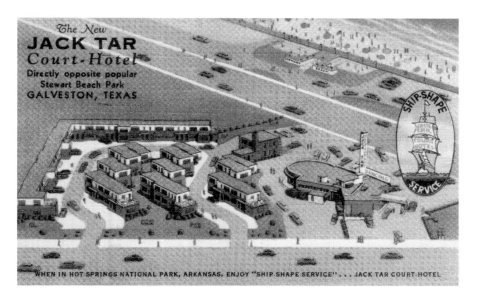

The Jack Tar sat on the triangular lot created with the first filling of the East End Flats, between Sixth Street (*bottom*) and the eastward extension. *Rosenberg Library.*

county officials were staunchly opposed to using it to generate revenue for the city. The county attorney prepared a resolution for the Galveston Board of Commissioners, expressly outlining the county's financial objections as well as the concern of the danger posed by meters in the event of a hurricane. The city commissioners approved their installation anyway with an official vote on July 10, 1941, that both outlawed parking completely on the south side and implemented paid parking on the north side of the boulevard between Fifteenth Street and Thirtieth Street. The county promptly took the matter to the Fifty-Sixth District Court and was granted a restraining order against both the City of Galveston and the company hired for the meters' installation, and an appellate court upheld the political maneuver until the Board of Commissioners acquiesced.[6]

Sam and Rose Maceo were, of course, happy to provide a welcome distraction from the government's shenanigans when they decided to reinvent their restaurant on the water into a full-scale dinner and dance club. The Hollywood Dinner Club had gone the way of the Grotto in 1939 when it was forcibly shut down, but the success of the Sui Jen spurred on the empire. Plans were announced of an ensuing remodel that would surpass the beauty of any venue thus far. The pier of the Sui Jen Café was extended to a remarkable six hundred feet out into the Gulf, but the aesthetic of it was

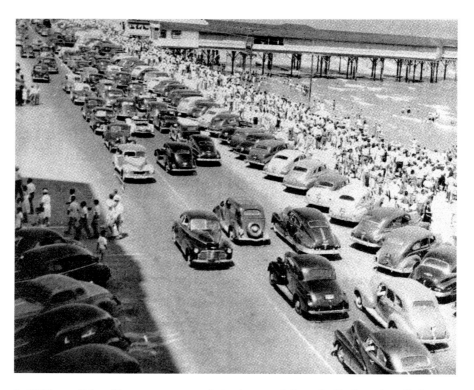

In 1949, parallel parking was permanently implemented along the Boulevard to eliminate the congestion caused by angled parking, shown here circa 1947. *Rosenberg Library*.

only part of its purpose.[7] The pier was the only way in and the only way out and not exactly convenient for law enforcement officials thinking about a spontaneous visit. The Maceo brothers slated their grand reopening for December 1941.[8] Unfortunately, the world had other plans that month.

In the early morning hours of December 7, 1941, the Japanese attacked Pearl Harbor. In one day, the United States went from sentimental supporter to country at war, and suddenly the Sui Jen's Asian motif went from exotic and enticing to entirely anti-American. The brothers were undeterred in their quest to reopen their new dinner club, however, and they pushed back their opening and hastened to fully revamp the club's interior. It metamorphosed into paradise incarnate at the hands of designer Virgil Quadri, who developed an elegant spin on a South Seas motif. He began by hand-painting murals around the dance floor that depicted native dancing girls and tropical beach scenes. Quadri then incorporated free-standing golden palm trees, a large aquarium and a stunning lounge area covered in various shades of red and

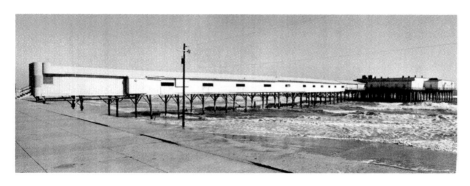

The pier of the new Balinese Room stretched six hundred feet out over the Gulf of Mexico. *Rosenberg Library*.

The original entrance to Galveston's famous Balinese Room, which would become a landmark of the seawall. *Rosenberg Library*.

orange; he is also credited with recommending to Sam Maceo that the club be renamed in accordance with its transformation.[9] The name he suggested was one that still today echoes through time as a hallmark of Galveston's past, and the Balinese Room opened to a top-tier crowd on January 17, 1942. It was a seamless transition of the Maceo legacy, as the Balinese Room quickly became the brothers' most famous establishment, with Sam continuing to attract top-notch performers and Houston tycoons. Despite numerous efforts by the Texas Rangers to uncover criminal enterprises in Galveston, the Balinese Room would remain untouched and unrivaled for the next fifteen years.

As 1942 progressed, the threats of German U-boats in the Gulf of Mexico became apparent, and the two military outposts in Galveston found themselves preparing for active duty. Fort Crockett and Fort San Jacinto, fully protected by the extensions of the seawall, were being called on to protect the entrance to Galveston's harbor and the Houston Ship Channel. Previously dormant and with no developments since the 1920s, the two military installations suddenly began to receive significant fortifications, and visitors were now prohibited at the bases for the duration of the war.[10]

On the far eastern tip of the island, machine gun emplacements were imbedded into the seawall in front of Fort San Jacinto. They posed a fatal traffic hazard, so after the war, the upper parts were removed and the wall was repaired with concrete.[11] On the opposite end of the seawall, Fort Crockett occupied 125 acres between Thirty-Ninth Street and Fifty-Seventh Street, situated on the southwest corner of the established city limits at the time, and it underwent a massive modification when an antiaircraft battery

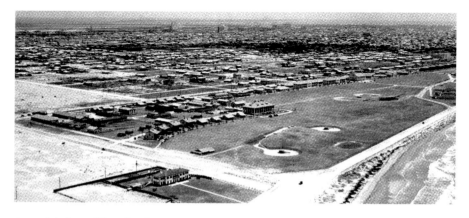

An aerial view of Fort Crockett, which was heavily outfitted in 1942 to protect the Texas coast. *Rosenberg Library*.

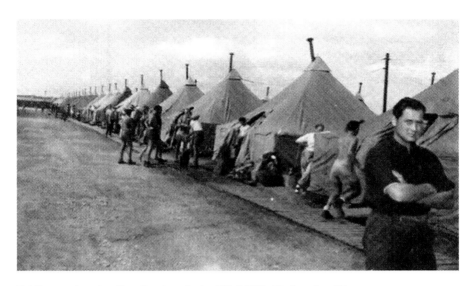

Soldiers stationed at Fort Crockett during World War II. *Rosenberg Library*.

was installed secretly between 1942 and 1943. Called the Battery Hoskins, its guns were visible from the air until the Army Corps of Engineers encased the battery sufficiently enough to withstand five-thousand-pound naval shells. Fort Crockett was also outfitted with one-hundred-foot watchtowers, searchlights, ten- and twelve-foot gunneries, more antiaircraft batteries and equipment for monitoring marine traffic.[12] But the most advantageous addition to the military sites in the 1940s were the soldiers themselves, who provided the seawall and the city with a perpetual stream of business.

Amid these wartime intricacies, Mayor Harris was in the final year of his service to the city. Despite his unsuccessful attempt to develop the East End Flats, as a swan song, he had been able to launch two quite enterprising ideas that did indeed take hold. The first was the creation of Stewart Beach, located toward the east side of the seawall just across from the Jack Tar. Harris formulated a mental blueprint of a full-service beach arena and entertainment area that was fully realized in 1941. In addition to restrooms, showers, changing areas and a gift shop, the original Stewart Beach also included areas for surf-bathing, skating, tennis, surfboarding and dancing, as well playground equipment and eventually even a miniature golf course.[13] Although much of its fanfare has since been eliminated, the amenities remain, and Stewart Beach is still today one of Galveston's most popular beaches.

An artist's rendering of the Jack Tar shows the newly added Stewart Beach located across the Boulevard. *Rosenberg Library.*

Harris was also the mastermind behind the original Pleasure Pier, one of the city's most historically famous attractions. In July 1942, the mayor announced his vision of a pier that extended far into the Gulf, and atop it would sit an all-inclusive entertainment venue where young people and soldiers could go dancing and find other modern amusements. Construction began almost immediately.[14]

Islanders were busy with the idiosyncrasies of wartime life—price controls, gas and sugar rations, scrap drives—but they wholeheartedly embraced the continuation of Galveston's commercial development. In fact, they saw it as necessary, as the island was fast becoming a refuge and retreat for the military stationed on the coast. Between 1942 and 1943, German U-boats sank 116 ships in the Gulf of Mexico, but this very real threat to the Texas coast still did not deflate the city's progress—shockingly, neither did the establishment of Fort Crockett as a prisoner-of-war camp. In November 1943, Galveston received its first detainees, 165 German troops from a North African conflict. At its peak, Fort Crockett housed 650 prisoners.[15]

Construction on the $1.5 million Municipal Pleasure Pier at Twenty-Fifth Street and Seawall Boulevard was briefly interrupted for use as an air depot during the war, but at last, it was presented to the public on June 15, 1944. Unfortunately, the monstrous pier that jettisoned 1,130 feet out over the Gulf

of Mexico was not enough of a novelty to counteract the hot, windowless, metal ballroom that "drew little more than flies."[16] The highly anticipated Pleasure Pier was closed at the end of the same summer that it opened, but its final fate was yet to be determined.

The next year, the hurricane of 1945 struck as a category 3 storm on August 28 and battered an entire third of the Texas coastline. From Corpus Christi, where cotton crops valued at $1.5 million were destroyed, to Port Lavaca, where a fifteen-foot storm surge caused nearly $1 million in damages, every coastal city was affected by this monstrous storm. Galveston was not spared a direct hit, but because of the seawall, the island city was completely unaffected by the storm surge and sustained only inconsequential damage from the wind.[17]

Five days later, World War II ended, and the collective rejoicing over the conflict's termination yet again invigorated the city's commercial and municipal interests. The city presented another $380,000 bond proposal to the voters in November 1945, and it was even championed by the dean of the University of Texas Medical Branch, who attested that the current undesirable conditions of the flats were an impediment to the comfort of their patients and furthermore a "danger to the health and welfare of the city."[18] Even still, voters voted down the proposition and did so again, two to one, in 1946 in what would be the city's final attempt to pacify the property owners.

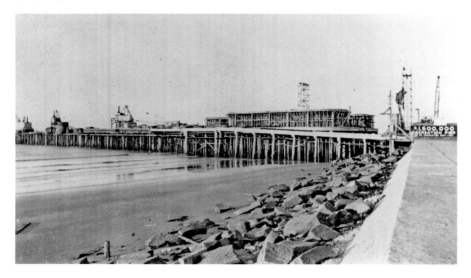

Construction of the original Pleasure Pier at Twenty-Fifth Street. *Rosenberg Library.*

The city was also tasked with deciding what to do with the Pleasure Pier, which had been vacant for nearly two years, when a group of local businessmen stepped forward. W.L. Moody, Sam Maceo and H.S. Autrey formed the Galveston Pier Corporation and signed a ten-year lease on the property.[19] They executed nearly $200,000 in improvements, such as air conditioning and new carpet, drapes and tables. A ballroom, an aquarium, a museum and a convention hall were punctuated by a thirty-six-thousand-square-foot exhibition hall and a 1,500-seat outdoor movie theater at the end of the pier that practically floated alone out over the water. The Pleasure Pier triumphantly reopened on May 29, 1948, six years after the onset of the concept, and Harris's forward thinking was finally fulfilled.[20]

As the 1940s drew to a close, the raising of the unfilled areas of the East End Flats was at last completed with funds from the private landowners, who finally accepted their lot. This allowed for the city's expansion; in 1949 alone, the Sealy & Smith Foundation, owner of nine blocks within the flats, constructed four apartment buildings. Shortly after, plans for the first residential subdivision on the filled area were announced. Lindale Park would consist of 182 smaller low-cost single-family homes, and over the next five years, two new subdivisions would be completed, San Marino (1952) and Harbor View (1954).[21] Sixth Street was officially no longer the far eastern edge of town proper, and the original eastern arm of the seawall would never again see the light of day.

The year 1949 also witnessed the demolition of the now-defunct Crystal Palace, which was cleared to make way for a modern development, and along Seawall Boulevard, parallel parking was permanently implemented, greatly easing traffic congestion on the roadway.[22] Most importantly, Galveston gracefully displayed the same resilience during war that it had during the Depression, and with a little added magic from the Maceos, the local population was shielded from yet another decade of tribulation. Wading through war, prisoners and yet another hurricane, islanders had taken it all in stride, and the city was poised to continue its reign as the "Port and Playground of the Southwest."[23]

INNOCENCE AND INIQUITY

1950s

The "Free State of Galveston" was to exist no more, except in the hearts and memories of her people.
—David G. McComb[1]

T he year 1950 ushered in an era that would provide enough nostalgic wax to keep its memories shiny and clean well past the turn of the century, and the Galveston Seawall was not immune to the picturesque trappings of the decade's culture despite the stark, intriguing contrast of Galveston's underground circuit and backdoor enterprises. But in actuality, the charming backdrop of drive-ins and sock hops was indicative of a mindset that would eventually parlay the island's beneficial albeit alternative economy into the object of a witch hunt.

After a brief recovery period following World War II, Splash Day and its popular beauty pageants were revived, and the bunkers of Fort Crockett, empty yet again, became a playground for children who would play hide-and-seek in the deep recesses of concrete and slide down the grassy hills of the battery on cardboard boxes. The west side of the military camp turned playground ran along 57th Street, the western city limit and boundary of seawall development until 1952.[2] On December 18 of that year, the area westward to 103rd Street was officially annexed into the city of Galveston, and shortly thereafter in 1953, a new beach park opened at 57th Street. West Beach beckoned visitors in that direction with $10,000 in amenities, including playground equipment, tables, barbecue pits and showers.[3]

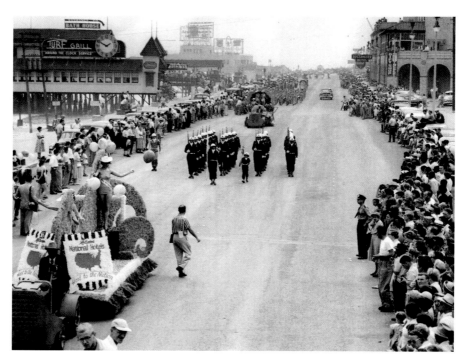

A 1953 parade in honor of Splash Day, the annual kick-off to the summer season that was revived in the 1950s. *Rosenberg Library*.

On February 1, 1950, plans were released for a new band shell at Menard Park, situated between Twenty-Seventh and Twenty-Eighth Streets. A fixture of the seawall since 1914, the park was originally established as a public resting area but had recently grown to include a small wooden roller coaster, a racing carousel and a wooden band shell for live music performances, which was now being torn down to make way for the more solid structure. The *Galveston Tribune* raved about the new band shell, which featured a "most modern design" that included all of the latest advancements in acoustics as well as a full lighting system with recessed illumination and spotlights. Plans were already being made for the upcoming summer season, during which Menard Park presented live band concerts twice weekly.[4]

The Jack Tar Hotel was remodeled and expanded in 1952, adding lush, elegant landscaping and a gorgeous swimming pool that replicated the millionaire lifestyle. Across the street, Stewart Beach remained as the unofficial eastern boundary of seawall activities, and its boardwalk, food bars, bathhouses, skating rink, kiddie land and dancing pavilion were some of

Fort Crockett sat on the southwest corner of the city limits until the area between 57th and 103rd Streets was annexed in 1952. *Rosenberg Library*.

On the right side of this updated artist's rendering of the Jack Tar Hotel are the new additions added to the property in 1952. *Rosenberg Library*.

the most sought-after attractions on the Boulevard.[5] Adventurous teenagers, however, would defy that border and cruise past it on the wall toward East Beach and the South Jetty Lighthouse. Down this desolate stretch of road, the seawall was fortified with a concrete embankment nicknamed Cherry Hill, where they would hold drag races and go parking.

Indeed, while the adults were engaged at the slot machines and card tables, the seawall's culture was rapidly evolving with the infiltration of

Aerial view of Stewart Beach. Its numerous amenities made it one of the most popular beach locations on the seawall. *Rosenberg Library.*

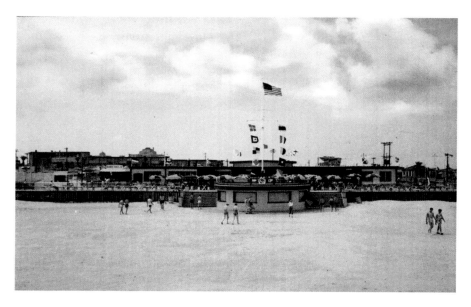

The entrance to Stewart Beach in the 1950s. *Rosenberg Library.*

A group of teens outside Boulevard Drive-In on the seawall, circa 1956. *Personal collection of Bob Whelton.*

1950s teenage culture. Throughout the decade, the Boulevard was emblematic of the period with a hierarchy of gathering places along the way and a perfect view for cruising in a hot rod. Kids would drive up and down the seaside strip from one drive-in to another looking for people to see and something to do. It was the place to see and be seen, and the drive-ins were the place to hang out even if no one ordered food.[6] Many of them even had a sit-down restaurant where the jukebox occasionally turned the dining room into a dance floor.[7]

The first and longest-standing drive-in, Keith's, was located on the northeast corner of Tenth Street and Seawall Boulevard. Owner Keith Montgomery happily peddled his "extra special" Coney dog and poured creamy "TRIPLE XXX" Root Beer from a seven-foot-high 1,200-gallon barrel into a frosty frozen mug.[8] His 1947 business was joined in the '50s by several other seawall drive-ins, but they all seemed to peacefully coexist, each of them having carved out their own special character and uniqueness.

The Surf Drive-In was located between Thirty-Seventh and Thirty-Eighth Streets and ran a string of articles in the *Galveston Daily News* that hyped its "real, old-fashioned, hickory-smoked barbecue"; it also served up delicacies such as stuffed crabs.[9] Boulevard Drive-In on Thirty-Third Street was one of the most popular among teens at the time and featured twenty-five-cent hamburgers and chili and spaghetti, an odd but delicious specialty. On the corner of Twenty-Fifth Street and the Boulevard was the ultimate gathering place, Pier Drive-In, and it became known as the most likely place to find guys showing off their custom cars.[10]

Hot rod culture was a predominant theme on the seawall in the 1950s, the decade when fledgling technology was making its way into the hands of a generation of automobile enthusiasts who were no longer content with assembly line vehicles. The most popular kids at the drive-ins were the ones with the cool cars and the big mufflers, but it was not truly a hot rod unless

Left: Cheerful carhops in satin pants were a staple of the 1950s drive-ins. *Personal collection of Bob Whelton.*

Below: Teenage guys showing off their custom cars, circa 1956. *Personal collection of Bob Whelton.*

The car club called the Galveston Road Runners shows off one of its hot rods on a float in a parade down the seawall in the mid-1950s. *Personal collection of Bob Whelton.*

it was customized. In addition to custom paint jobs and engines, the chrome and door handles were removed from the cars, and panels of buttons were installed that controlled everything. Once in Galveston, the son of a wealthy businessman bought a brand-new Cadillac and drove it straight over to the garage where it was outfitted with the latest gadgets and painted a stunning shade of purple. Dubbed the "Ladybird," gold powder was mixed into the car's iris paint job, making the glow was visible from a block away.[11]

Groups of friends formed car clubs with names like the Night Riders and the Rev Masters that would participate in formal parades down the seawall. Another club called the Road Runners also hosted an event called "AutoRama" that was held at the Pleasure Pier. Entrants paid one dollar for the ability to see dozens of local custom cars all in one place. Clubs would have metal plaques made to hang below their rear license plates to announce their affiliation, but former members attest that nothing more than a friendly rivalry existed between the different clubs.[12] The only theatrics came when a one-on-one verbal challenge, usually made at a drive-in, resulted in a parade of vehicles speeding east down the Boulevard to Cherry Hill. Surrounded by a crowd of enthusiastic spectators and overlooked by couples parking up on the concrete hill, the two vehicles would square off atop the eastern leg of the seawall. The police were never unaware of what went on down this stretch of road, but they pretty much

left the parkers alone, and by the time they got wind of the drag races, the crews were usually already back at the drive-in.[13]

Thus was the squeaky-clean backdrop against which Galveston's flirtation with the inevitable would lead to a marriage of inconvenience. The palpable innocence of tight-rolled jeans and white T-shirts would provide a much-needed buffer when once again the city suffered tremendous loss and yet another unsolicited redesign of its economy.

Sam Maceo remained fastidious in his campaigns to lure more tourists, gamblers and convention attendees to the island until his death, but unfortunately, that came sooner than anyone expected. On April 16, 1951, Salvatore "Sam" Maceo died of cancer, and the effect of his death was felt even more than the far-reaching influence of his life. The cloud that rolled onto the shores of Galveston with his passing was further darkened by a fire that gutted the Balinese Room on March 8, 1953, and Rose's death one year later on March 29, 1954. The brothers had been grooming their nephews Vic and Anthony Fertitta to take over their Galveston operations since the late '40s, when they decided to transfer some of their interests to Las Vegas. Gaming had long since been legal in Nevada, making it harder and harder to attract both customers and entertainers. Furthermore, the Fertittas simply

Road Runners club members display their custom jackets that were charcoal gray and pink, an homage to a new Cadillac that had just been released. *Personal collection of Bob Whelton.*

did not inspire the same trust and loyalty as their uncles, and likewise they were unable to maintain the degree of political and social influence needed to sustain business.[14]

The Maceos had been acutely aware of the fact that the respect afforded to them by local residents was their biggest protector. "Since the law was the enemy of the Maceos, then the law was the enemy of the people of Galveston County. This community participation of protection exasperated the [Texas] Rangers."[15] However, the established ties between underground and aboveboard began to weaken under the leadership of the Fertittas, and when the two brothers attacked a reporter in the lobby of the Hotel Galvez, they unraveled completely. The reporter's name was Henry Snydam; he worked for *Life* magazine, and he followed up the incident with a piece titled "Wide-Open Galveston Mocks Texas Law."[16] It was not only damaging to the national reputation minted for Galveston by Sam Maceo but also embarrassing to both the local population and state officials, who had begun conducting raids every month in the late 1940s and desperately wanted to rid Texas of gambling and prostitution.[17]

To no surprise, the final undoing of Galveston's syndicate came at the hands of newly elected attorney general Will Wilson, the moral vigilante who was elected almost solely on a platform of shutting down the city's illicit activities. He wasted no time in pursuing this end when he was chosen for the office in 1956. Wilson set up the Texas Rangers at a hotel near the Balinese Room, but their frequent raids were always thwarted by the long pier that connected the entrance to the club. By the time they got to the back rooms, gamblers had been alerted by a signal from the front desk, and all evidence had "vanished." Trying a less overt tactic, the Rangers began to simply show up to the club and sit there, all day, every day. Business suffered, and then a raid devised with undercover agents was the last hurrah. The B-Room, as it was affectionately called, closed its doors on May 30, 1957.

The unbridled enthusiasm of the local population diminished along with Sam's presence, and it was further thrust into an abyss of shame and humiliation after the city became a target of the media and now the state. Once Wilson's plans were completed and Galveston was unwillingly rid of all of its vice, life along the seawall limped along, hoping to forget its pain by bopping to the projected incorruptibility of the 1950s.

The Pleasure Pier was still in operation and hosted sock hops in the Marine Room ballroom eight times a week, and its Golden Garter tavern was the site of a stage show called the "Gay 90s," where "Garter Girls" would dress in period costumes and perform nineteenth-century

melodramas. The exhibition hall was transformed into a carnival midway, and the pier also offered deep-sea fishing and carnival rides like a Ferris wheel and tilt-a-whirl.[18]

In 1958, the Army Corps of Engineers began its final extension of the seawall with combined contributions from federal and county funding. The project originally began in 1953, but with the onset of the Korean War only one mile of it was finished. Five years later, the completed extension would take the seawall westward another two miles and bring its final length to nearly ten miles, cementing its rank as the longest continuous sidewalk in the world.[19]

HER NAME WAS CARLA

1960s

[The year] *1965 brought the salty old-timer some adornments that have perked her up considerably. Long the queen of Texas resorts, Galveston shows her age—but a few new baubles can make her shine again.*
—Texas Magazine[1]

Even before the raids of 1957, Galveston had been fast losing ground to Las Vegas, and its waning popularity resulted in a rapidly diminishing presence of elite clientele on the seawall. In a Galveston Chamber of Commerce meeting in 1955, a prominent local citizen made a remark that was quickly picked up as a local inside joke. "Two men came over the Causeway with a white shirt and $5.00—and they didn't change either."[2] After the raids, the prestige of Galveston vanished completely, and the seawall became but a casual amusement. Year-round business had also plummeted, and the city found itself relegated to summertime beach-town status. The steep downturn of both the quantity and the quality of visitors gutted the island of both residents and businesses, and the city was forced to adapt to the ruin of a system that had supported it for thirty years.

Four years later, Galveston was still bleary-eyed and weary when the sorrow was further amplified by another bout with nature. Hurricane Carla, Galveston's first named storm, struck on Saturday, September 9, 1961, and flooded 95 percent of the island. The storm resulted in no fatalities, and every home was left standing with minimal flooding only from the bayside. However, tornadoes from the storm caused significant wind damage and

A 1961 view of the Mountain Speedway right before it was demolished. *Personal collection of Jan Johnson.*

destruction along the Boulevard.[3] If Will Wilson took Galveston's queen, Carla was checkmate.

A silver lining around Carla's cloud was found in the fact that the Mountain Speedway had been demolished earlier that year; the cleanup that was accomplished relatively quickly after the storm was felt to be even more expedient considering the mess that the roller coaster would have left behind. But for many more years, the sensation and spectacle that had for so long defined life on the seawall would remain nothing more than a vague recollection. The Pleasure Pier suffered heavy damage and all operations ceased; the Seventeenth Street Fishing Pier was obliterated. In 1962, the *Houston Post* assessed the condition of Galveston one year after the storm, and estimated that the city had suffered $127 million in damages and, in a vivid but dismal observation, reported that "the Balinese Room still stands, weakly, as if calling for an executioner." Other sources reported that the total damage from Carla in Texas exceeded $300 million.[4]

Some businesses persevered from the 1950s, like the Silver Shell Gift Shop and Keith's Drive-In, and the old die-hards like Gaido's and Hotel Galvez stuck around through the bleak years that followed, as did the Jack Tar and Buccaneer Hotels. Stewart Beach added a miniature golf attraction named the Peter Pan Golf Course, and Murdoch's razed the damaged bathhouse and souvenir shop but rebuilt it immediately. Soon after, a new hotel, called the Seahorse, on the Boulevard between Thirty-Third and Thirty-Fifth Streets managed to spark a bit of interest with its curved panoramic glass walls, sprawling lawn and luxury swimming pool.[5]

The seawall also received a much-needed impetus from the same demographic that had saved it once before—teenagers. The kids who wanted to dance and their constant requests for upbeat music in the late 1950s helped create the sensation that had come to be known as rock 'n' roll, and their

Sock hops gave way to hip-shaking dance clubs like the Bamboo Hut. *Rosenberg Library*.

continued search for progressive music in the '60s ushered in a new trend on the seawall. The wide-eyed ballads of the sock hops had given way to the hip-shaking beats of dance clubs on the beach.

The Bamboo Hut, located on the beach side of the seawall at Seventh Street, was originally a concession stand that opened in 1962, but the owners sniffed out the current demands and enclosed part of the property to make a dance floor. The club attracted several popular bands from the Houston area and beyond with acts like the Boogie Kings from Louisiana, the Five Dominoes and the Countdown Five. The Bamboo Hut was an all-day beach party that served sandwiches, pizza and hot dogs, and teenagers danced every night under the stars and on the sand.[6] Piggybacking off its success, another club, called the Grass Menagerie, opened just to the west, and suddenly the seawall had yet again become emblematic of a generation.

A cautious optimism began to infuse the spirits of locals, despite the deluge of losses from the past five years. When yet again faced with events that threatened its very existence, the city of Galveston had once again climbed its way back from the mire. Within three years of Hurricane Carla, the 1964 city directory speculated that "the historian of 20th century Galveston is likely to chronicle the year 1964 as the beginning of its promising Renaissance." Indeed, the seeds of revitalization were planted that very year, and in 1965, Galveston received a huge jolt by way of two new monstrous developments: the Flagship Hotel and Sea-Arama.

Even before Carla, the old Pleasure Pier had failed to produce its projected revenue, which made its damage from the storm not worth repairing. The pier at Twenty-Fifth Street sat desolate and empty until someone conceived the idea to renovate it and build a hotel resort in place of the amusement park. The Nide Corporation entered into a twenty-year lease contract with

the City of Galveston to maintain what would be called the Flagship Hotel, the only resort hotel in America built over the water.[7] Construction began in mid-1964, and the awe-inspiring complex opened on June 30, 1965. It included restaurants, bars, parking, luxurious accommodations and an above-deck swimming pool.[8]

A few months later and several months behind schedule, the spectacular marine park named Sea-Arama opened on November 7. Built partly in an effort to spur year-round visitation to the island, it was predicted to cost $1 million, but by the time it opened, the cost had more than doubled.[9] Sea-Arama was located on the far west side of town; the mammoth steel-and-concrete attraction was constructed on a twenty-five-acre site at Ninety-First and Seawall. It was one of the first facilities of its kind.[10] The centerpiece of the state-of-the-art complex was a massive circular building called the Oceanarium, in the center of which was a 170,000-gallon tank that held the larger species of the deep that swam free. The walkway that encircled it was lined on the other side with dozens of tanks that housed hundreds of specimens individually, ranging from brightly colored coral reef swimmers to the surreal forms of bottom dwellers. Outside, audiences of one thousand people filed into the Aqua Amphitheatre and Porpoise Theater to watch the trained mammals perform live with their trainers.

Sea-Arama was also esteemed by the professional community as a forerunner in innovation and technology within the oceanographic community. A pipeline ran from the Gulf of Mexico, under the seawall and into the park to provide a fresh supply of salt water that would be filtered before used to fill the tanks.[11] It also incorporated one of the first-ever "show pools," a porpoise tank encased in glass that is a hallmark of parks today.[12]

From new novelties to old standbys, the year 1965 also brought with it the purchase of the fated Balinese Room. After sitting vacant, unwanted and in disrepair for nearly ten years, it was purchased by a man named Johnny Mitchell after a public auction yielded not one bidder. He completed a $150,000 renovation, including adding the Asian-inspired façade[13] that would define its appearance for later generations so much so that it has often been incorrectly associated with the Maceos. The official reopening of the Balinese Room took place on May 22, 1966, and what it was missing in entertainment it made up for in nostalgic appeal.

In the latter years of the decade, the Sea-Arama Corporation invested an additional $1 million into expansions and additions to their already sought-after marine park. Some $520,000 in improvements were made in 1968, and then another $410,000 was spent on new shows and attractions that

Sea-Arama was a multimillion-dollar marine park that was the most modern attraction of its kind when it opened in 1965. *Rosenberg Library*.

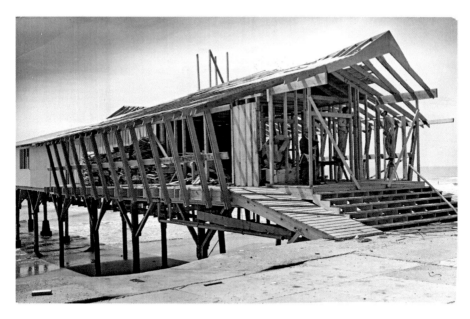

Under new ownership, the entrance to the Balinese Room was modified into an Asian-inspired façade that would define it for the next thirty years. *Rosenberg Library*.

An aerial view of the Sea-Arama "marine world complex." *Rosenberg Library*.

catapulted Sea-Arama from an aquarium into a "marine world complex."[14] The complex was blanketed with lush landscaping and a three-hundred-foot lagoon, and a thirteen-foot waterfall was installed to heighten the atmosphere. The grounds were also outfitted with a snack bar, a gift shop, the Pink Porpoise Ice Cream Parlor and the Pirate's Nook Restaurant to make the experience more all-inclusive. They added a Mermaid Scuba Show, a Water Ski Comedy and a Gator Swamp & Reptile House that put on alligator wrestling and snake shows. Sea lion and seal feeding and a dolphin petting zoo were added for more interactive involvement, and a large air-conditioned cave led to an ominous view of a giant octopus.[15] Popular characters over the years were Otto the Performing Otter, the Penguin Chorus Line and whales Nemo and Mamu, which established Sea-Arama as one of only four parks in the nation with a resident killer whale.[16] The city marketed the park as "one of the most unique and complete multi-million dollar marine attractions in the world."[17]

With the economic buttress of the Flagship Hotel and Sea-Arama Marine World, Galveston regained some of its financial footing. Time had

succeeded in fading the bitter memories of lawmen and hurricanes. Slowly, the vacant buildings on the Boulevard began to fill in with business hopefuls, confident in the prospect of yearlong interest in the island, but still, somehow something was missing. Perhaps proprietors on the beachfront had simply outdone themselves far too many times and for too many years, or perhaps the accumulation of destruction was too disheartening, but for another forty years, seawall culture would struggle to reclaim its grandeur.

A FOUNDATION FOR THE FUTURE

1970s, '80s AND '90s

Galveston's tourism industry is winning its battle against an age-old stigma. On both the homefront and in faraway cities…people are discovering there is more to see and do in Galveston than visit the beach during summer.
—Galveston Magazine, *1985*[1]

At the point when the next century suddenly became closer than the last, the seawall had survived two wars, a depression, raids by the Texas Rangers and four hurricanes. But the sidewalk by the sea had grown weary under the weight of its troubles. Galveston lost its identity twice—first to the Port of Houston and next to the scruples of a selective American morality—and the last three decades of the twentieth century would see the island community struggle yet again to redefine itself.

Even though Galveston had always been a beach town, this was the first time in its history that it was seen as *only* a beach town. The glory days of the late 1800s were long since faded from generational memory, and when Texas proved to Galveston that it was not in fact "free" or a "state," the backlash decimated any reputation the island had among the elite. Gone were the braggart promoters hailing the "Treasure Island of the South," and their poetic dedications were replaced with an incessant murmur of unrest among the local population as city officials floundered to regain the seawall's footing as a prime destination amid a tourist population that was growing in number but declining in value.

Instead of planning new amusement parks and devising clever gimmicks to draw crowds, the municipalities were instead consumed with managing

The seawall became a go-to spot for the new trends of the 1970s like skating, skateboarding and surfing. *Rosenberg Library.*

the bureaucracies of a town that was at the same time dependent on and resentful of its new classification as a place for a cheap daytime or weekend getaway. Still, the struggles would turn out to be nothing but growing pains, and the final trifecta of the 1900s would prove in hindsight to be the maker of a firm foundation on which the twenty-first century could build.

At the start of the 1970s, many of the businesses of the '60s that had emerged or rebuilt in the aftermath of Hurricane Carla remained, but as the decade progressed, the seawall itself did not. The large hotels—the Seahorse, the Jack Tar and the Buccaneer—managed to still evoke moderate interest, but no further developments of their kind were put in motion. The

seawall did, however, manage in some form to keep pace with the evolution of American culture.

The arrival of video games on to the cultural scene generated much excitement, and fast food was also steadily gaining market share among the nation's population. As the relevance of drive-ins as a social activity waned, they were replaced with the Galveston Arcade, as well as Galveston's first Kentucky Fried Chicken and an early Jack in the Box, the latter of which remains in its same location today.[2]

In 1973, two plans for further extending the seawall were examined. One recommended building a wall to encircle the city limits, and the other was for a westward extension. Backed by the chamber of commerce, the proposal for the westward extension was most highly advocated.[3] At the time, major development in the city still ceased around Sixty-First Street except for Sea-Arama, but some moderate residential construction was taking place farther west, mainly the modest homes of shrimpers and others who made their living off the water. City officials argued that this area, too, needed protection from a potential hurricane, but they were unable to produce a sufficient benefit-to-costs ratio. The proposal was vetoed by the Army Corps of Engineers, which protested that there was inadequate justification for a project that would cost upward of $55 million. In 1974, the corps' definitive denial laid the issue to rest permanently.[4]

By 1979, city records indicate that Galveston was welcoming over 4.5 million visitors annually, up from 2 million in 1970, but overall it appeared that the Boulevard had transitioned from a destination full of sites and adventures to merely a place to hang out.[5] In the February 1974 edition of *Galveston Magazine*, Jack Bushong, president of the Galveston Convention and Visitors Bureau, lamented, "We do not have enough recreational facilities in the daytime and without a doubt we do not have enough nighttime entertainment."

The resurgence of interest in Galveston seemed mainly due to the steadily increasing popularity of skateboarding, surfing and roller skating. Only a novelty to some, by mid-decade, professional contests were being held nationwide for both skateboarding and surfing, and the draw of these extreme sports carried over to the local amateur talents eager to use the seawall and Galveston beaches to hone their skills and socialize.

Stores opened along the waterfront in an effort to capitalize on these new pastimes, such as various surf shops and the World of Wheels Skateboards. Even the city was forced to keep up with the added intricacies brought by these activities, and in 1976, city council passed a complete ordinance

dedicated to surfing in the Gulf, which included many safety restrictions that are still in place today, like designating specific areas for surfing and mandating that surfers maintain a safe distance from the jetties and fishing piers.[6]

As the clock struck 1980, the city formed the Seawall Beautification Committee and made reasonable efforts to improve its appearance, such as refurbishing Stewart Beach and the recently designated Appfel Park on East Beach, named after a former mayor. Still, Galveston seemed inevitably relegated to a fate of surfers, skaters, partiers and loiterers, when suddenly the 1980s bestowed upon the island the vision of one of the city's most revered champions, George P. Mitchell.

A Galveston native and a graduate of Texas A&M–Galveston, the renowned oilman, entrepreneur and inventor of fracking decided that his hometown was worthy of his financial investment. Before it was popular, before it was considered even a rational decision, Mitchell began to funnel money into what would eventually become the city's designated Downtown Historic District, rehabilitating the Victorian commercial buildings on Galveston's Strand Street and transforming them into a center of arts, shopping and urban residences. At the time of his death in August 2014, George Mitchell had donated over $300 million to the city through his philanthropic, restoration and rebuilding efforts.

The man in this 1980s photograph is carrying the trademark boombox of the day. *Rosenberg Library.*

Previously hailed as the "90 Day Wonder"—a tongue-in-cheek slight against Galveston's popularity only during the summer season—Mitchell's efforts infused a new life into the tired island city.[7] In the summer of 1985, *Galveston Magazine* proclaimed, "Galveston's tourism industry is winning its battle against an age-old stigma. On both the homefront and in faraway cities…people are discovering that there is more to see and do in Galveston than visit the beach during summer."

The growth of the downtown area on the island's harbor side managed to permeate the seawall as well, as Galveston again found favor with the upper crust of Houston society. Less than fifty miles away, the island proved to be a fantastic place for a weekend or vacation home, and the demand for this interest was met by a veritable building boon in the early 1980s, primarily in the form of condominiums. The stretch of seawall west beyond Sixty-First Street, before barren and completely undeveloped, soon became known as "Condominium Row."[8] The far eastern end of the seawall also began to capture the attention of developers for the first time. The area between Sixth Street and Fort San Jacinto was desolate, largely ignored until a pioneering high-rise development called the Islander paved the way. Not even a year later, it was outdone by the Galvestonian, which had sold over 60 percent of its units by the time construction began in 1982.[9] By 1984, the seawall boasted over three thousand condo units in total.[10]

Even Hurricane Alicia, which struck in 1983, did little to deter interest in beachfront construction, in part because the wall had again served as a valiant protector. The immediate years following Alicia witnessed the opening of several businesses that are now icons of the seawall, such as Mario's Italian Restaurant (1983), Benno's By the Beach (1983) and the first Landry's Seafood Restaurant (1986), which would eventually provide the namesake for one of Galveston's premier development companies of the twenty-first century. Landry's would eventually purchase the San Luis Resort built in 1984, another monolith of George Mitchell that was constructed on top of the battery of Fort Crockett.

But the Boulevard of the 1980s still had a glaring problem: alcohol consumption among young people and teens was escalating, and they used both the sidewalk itself and lots across the way, still vacant from Carla, to hold wild parties. When Jan Coggeshall was elected mayor in 1984, she pushed for her vision of the seawall as an "urban park," which meant encouraging visitors to line the concrete wall with their beach chairs, boomboxes and coolers full of beer to party and sunbathe.[11] But between the sitters, skaters, cyclers and planter boxes that had been installed along the wall in the 1960s,

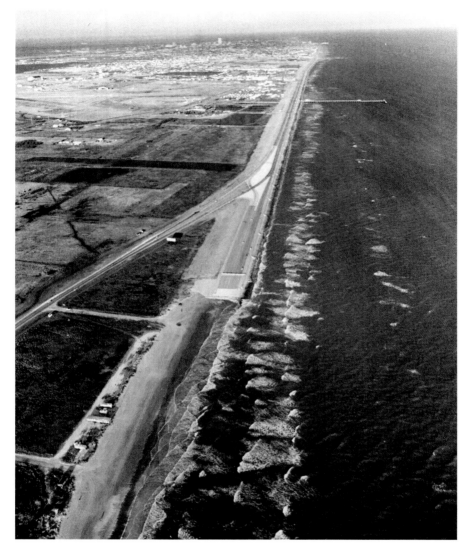

Where the sidewalk ends, the western end of the seawall after its final extension. Proposals to extend it farther were vetoed by the Corps of Engineers. *Rosenberg Library*.

Coggeshall's plan backfired tremendously and created a culture of disorderly conduct and a reputation that Galveston was not a safe place to visit.

Even Menard Park, which had for nearly a century served as a quiet respite for beachgoers, became overrun with indiscriminate visitors. Year after year, the *Galveston Daily News* printed editorials and opinion pieces

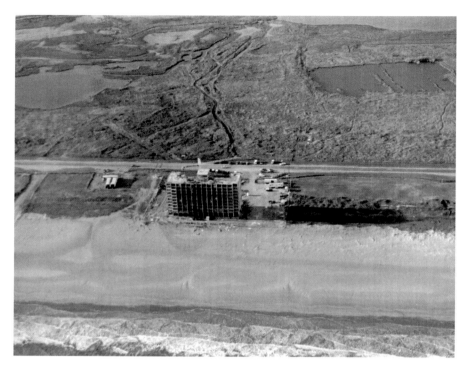

In the 1980s, the Islander was the first condominium to be erected on the desolate beach of the east end, south of the seawall, which is visible in the top left corner. *Rosenberg Library*.

on the "'monster' seawall problems," as locals expressed their disdain for the lackluster efforts of the city to curb violence and crowds. In 1984, a Seawall Task Force was created in an effort to devise a plan to overcome these obstacles, but its initial recommendations seemed to fall on deaf ears.[12] An entire two years after the task force presented its findings and suggestions to the public, the most controversial of which was a ban on alcohol, a sign was erected in 1986 along the Interstate 45 corridor to Galveston that read "Appfel Park—NOT FOR THE TAME," much to the dismay of local residents.[13]

On April 14, 1988, Galveston City Council at last followed the task force's advice and approved a ban on alcohol, but it would not actually be enforced until well into the next decade.[14] In 1989, the *News* published a scathing account of the seawall's ongoing situation, bemoaning stories of women "shaking from fear" at the sight of the tumultuous crowds, business owners declaring that people "would be nuts to shop down here" and law

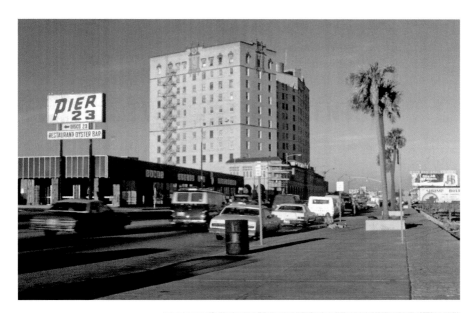

Above: In the background of this 1980s photograph, the once-grandiose Buccaneer Hotel was showing its age before its demolition in 1999. *Rosenberg Library*.

Right: The author skating on the seawall in the late 1990s. Decade by decade, the seawall reflected the fashion and entertainment that embodied each one. *Author's collection*.

enforcement who did not have enough "room in the jail for all the people they'd have to arrest to make a difference down here."[15]

Finally, in 1991, decisive action was taken to elevate the ambiance of the seawall. The alcohol ban was fully enforced to include both sides of the Boulevard and the beach, and in order to facilitate foot and bicycle traffic along the sidewalk, the planter boxes were removed. Most importantly, visitors were prohibited from setting up camp on the sidewalk.[16]

The remainder of the twentieth century's final decade would pass with little incident, instead proceeding at a slow and humble pace of growth that would both deny the seawall's past and usher it in to the future, all the while expanding farther and farther west. Magic Carpet Mini Golf, an amazing and creative spectacle that has defined the west end of the seawall for nearly thirty years, debuted in 1990, while the Jack Tar that held that distinction for the east side was demolished. In 1998, Galveston's first modern multiplex movie theater opened on the seawall at Eighty-Ninth Street, and that same year a small restaurant called the Spot opened. It would eventually quadruple in size and become one of the Boulevard's most popular attractions. In 1999, McGuire Dent Recreation Center was constructed on the site of Menard Park, and along with the demolition of the Buccaneer hotel, the bygone eras were now officially nothing but fond remembrances. The seawall had once again demonstrated itself to be as stoic as its island community, although neither of them were entirely sure what the new millennium would bring.

THE TWENTY-FIRST CENTURY

*[We] capture the feelings of being out in the water without a care in the world,
living a dream so many long to live no matter where they are from.*
—*Mike Love of the Beach Boys*

Life on the modern-day seawall is boisterous and colorful, teeming with novelty stores, restaurants, hotels and endless entertainment. Scattered among the throngs of beachside pleasures are the stoic remnants of the Boulevard's past, the ones that have managed beautifully the passing of the decades and shored up their timeless relevance. The foundation of this multifaceted personality is an accumulation of all that the seawall survived and celebrated over the course of a century, but the fervor of its current popularity can also be attributed to the city's unyielding response in the wake of yet another disaster.

For Seawall Boulevard, the turn of the century followed the slow but steady course of improvement set forth in the previous decades, and memories were still fresh with the victory over a beachfront culture that had for so long eluded the city's grasp. This heightened the Galveston community's sense of awareness regarding the delicacy of the seawall's reputation, and the city was fortunately able to attract a number of entrepreneurs who decided to capitalize on the need for quality dining and entertainment.

The Spot was sold in 2002, and the new owner was able to transform it from a bleak undertaking that was losing money every day to one of the most sought-after and popular destinations on Seawall Boulevard.[1]

The Spot, owned by Island Famous Inc. is one of the most popular locations on the modern seawall. *Author's collection.*

Landry's Restaurants was now plural, as the company gained a fierce momentum that catapulted it from a single restaurant to a far-reaching conglomerate.

Known today as Landry's Inc., the ubiquitous corporation includes several different restaurant concepts and hotels, including seawall hot spots such as the San Luis Resort, Fish Tales and Rain Forest Café. They were also responsible for the removal and demolition of the Seahorse Motor Inn at 3402 Seawall in 2005, a bittersweet event for the community. Many memories remained of when it introduced beachside luxury to Galveston in 1956, but it had since become a haven for drugs and prostitution.[2]

On the east end of the seawall, construction began on a new architecturally restricted residential neighborhood called Beachtown in 2006. The development would eventually be realized as a luxurious collection of massive, Victorian-style beach houses that energized the historic architectural template and infused the beachfront with a whimsical charm. Beachtown was also the precise location where the eye of Hurricane Ike made landfall on September 13, 2008.

At 2:10 a.m., a category 3 storm with a diameter of 600 miles and peak winds of 145 miles per hour struck Galveston head-on. The northern, bay side of the island was consumed with a storm surge that measured thirteen feet at its highest point, and along the seawall, monstrous waves toppled over the seventeen-foot-high concrete barricade. Seawall Boulevard did manage to escape flood damage, but the winds were merciless. Galveston had not witnessed such destruction since the 1900 storm.

Hurricane Ike was the final undoing for the forever-fated Balinese Room, sending it crumbling into the Gulf of Mexico along with Murdoch's, the one-hundred-year-old bathhouse turned souvenir store that was already on its fifth incarnation. The Flagship Hotel, built as a testament of survival in the wake of Hurricane Carla and a survivor of Hurricane Alicia, suffered irreparable damage and was permanently closed. The seemingly insurmountable seawall was strewn with huge piles of debris—heaps of memories and sorrow.

But as islanders had proven time and time again, they are unstoppable. Somewhat disoriented but otherwise unfazed by the destruction suffered at the hands of Mother Nature, the island community rallied once more to convert catastrophe into a catalyst for progress and creativity. As is typical following a disaster of this magnitude, many people left, never to return. But

Hurricane Ike left behind piles of debris along the Boulevard and severely damaged the sidewalk. *Courtesy of* Galveston Monthly.

The only thing left of the beloved Balinese Room at Twenty-First Street. *Author's collection.*

In 2009, Islander By Choice LLC revived the Beach Revue as an annual throwback to the original. *Courtesy of Galveston Island Beach Revue/Candace Dobsen.*

those who remained, remained undaunted, and the business sector ploughed ahead with a notion not only to regain but also to revitalize the attractiveness and allure of the Galveston Seawall.

The very next summer, a local company called Islander By Choice LLC debuted its annual Galveston Island Beach Revue, a modern tribute to the original Pageant of Pulchritude that once garnered international acclaim for the seawall. Every year on a weekend in May, the Beach Revue ushers in the summer season and celebrates Galveston's heritage with a complete festival featuring a Bathing Beauties Contest, live music and vendors.

Ike barely marked his one-year anniversary before Murdoch's reopened with a completely new structure. Still family owned after three generations, the beloved store led the charge and without hesitation rose to become the city's beacon of survival. Slowly and deliberately, businesses on the seawall followed its lead and either reopened or opened anew.

Unfortunately, an eyesore remained at the intersection of Twenty-Fifth Street: the haggard remains of the Flagship loomed over its pier as an inescapable reminder of yet another September day. In 1990, the building and operating lease was taken over by the Flagship Hotel Ltd., which signed a lease with the city through the year 2031. Over the years, several attempts were made to nullify the lease with accusations that the hotel was being allowed to fall into severe disrepair.[3]

In 2004, Landry's Inc. stepped in and purchased the property for $500,000 and promised to spend $15 million in renovations, but the lease—still officially intact—prevented it from moving ahead. The aftermath of Hurricane Ike revealed that the Flagship Hotel Ltd. carried only $3 million in windstorm insurance, far below the lease stipulation, which required $10 million. Landry's was able to renegotiate the lease and set forth plans for restoring the hotel.[4]

Several years later, the pier was still untouched. In 2010, the company announced that it had changed its plans. The hotel would not be restored. Instead, Landry's was going to build an amusement park over the water, an appropriate throwback to the property's historical relevance and a modern reinvention of the same. Landry's Inc. announced that the Galveston Island Historic Pleasure Pier would include a full-scale amusement park complete with a carousel, a roller coaster, a carnival midway and a Ferris wheel. During the spring of 2011, what remained of the Flagship Hotel was finally demolished, and as pilings were reinforced and steel was welded into shape, the construction generated a feverish excitement and ignited a new hope for Galveston's future. New businesses arrived steadily in anticipation of more

Once a marvel, the Flagship Hotel sat neglected for many years after Ike, until it was finally demolished in 2011. *Courtesy of* Galveston Monthly.

visitors to the seawall, and at last, the $30 million Pleasure Pier opened to an astonished crowd in May 2012.

That same month, Galveston residents voted to legitimately implement paid parking along the seawall for the first time in its existence, with the idea that the funds would be used to improve amenities along the beachfront. Although much talk has come from city officials and the current mayor that public restrooms and showers are soon to be added, the same need that has been neglected for nearly fifty years has yet to be reconciled.

One ongoing project that is nearing completion after many years is Project SIT, initiated by the local nonprofit organization Artist Boat to decorate the concrete benches that line the sidewalk. Over the past several years, individuals, organizations and businesses have all contributed to this beautification project by sponsoring benches adorned with mosaics of coastal marine life. Recently, Project SIT was the beneficiary of a sponsorship that guaranteed the project's 100 percent completion.

Beaches along the seawall have also recently received much-needed attention. In May 2015, it was announced that through the cooperation

In early 2012, construction was nearly complete on the new, updated version of Galveston's Historic Pleasure Pier. *Courtesy of* Galveston Monthly.

Large pipes discharge the fill used to complete a beach restoration on the west end of the seawall. *Courtesy of* Galveston Monthly.

of the Galveston Park Board of Trustees, the Texas General Land Office and the U.S. Army Corps of Engineers, the beach between Sixty-First and Eighty-First Streets would be replenished. After years of erosion that rendered sand practically nonexistent along this stretch, newly dredged sand was brought in to reconstruct one hundred feet of beach between

After the restoration. Before it was completed, the Gulf of Mexico was encroaching on the wall at this location. *Courtesy of* Galveston Monthly.

An aerial view of Galveston's 2015 beach restoration, named one of the top five in the country for that year. *Courtesy of* Galveston Monthly.

the seawall and the Gulf, an achievement that the American Beach and Shore Preservation Association named one of the top five beach restorations in the nation.[5]

Over the seawall's centennial of existence, the engineering marvel that was once thought of as merely a protector against destruction and loss of life has become the city's lifeblood all of its own. The seawall has indeed remained a valiant defense amid a century's worth of storms, but its Boulevard has also been a constantly changing, ever-innovating and always alluring facet of Galveston's identity and economy.

In each era that it has existed, the seawall has morphed to accommodate the trends, fashions and cultures of generation after generation. It has fully embraced and embodied one era to the next, forever an evolving microcosm of national culture. Today, it triumphantly stands as more than a survivor of storms; it is a window into the past that illuminates the evolution of societal movement. At the same time, it plays host to one-hundred-year-old businesses like Gaido's and Murdoch's that have remained stalwarts of the island through unprecedented change.

No matter what wave of time has encroached on the city, the Boulevard has exemplified the concave wall on which it was built, deflecting the trials and hardships of the rest of the world away from the island people. The seawall is both a monument to and a symbol of a tenacious and invincible town. It is both a wall of concrete that saves the city from physical destruction and a boulevard that has been, time and time again, the savior of its economic and cultural fabric. For the city of Galveston, the seawall is both a beacon of hope and the promise of a future.

Between the sporadic roars of the roller coaster on Pleasure Pier can be heard the historic echoes of an anxious crowd that once lined the Boulevard to catch a glimpse of the beauty pageant parade. In the last moments before the sun fades into the horizon, a vacant grassy lot seems to shimmer with the sparkling shadows of Electric Park. As the surrey bikes blow past with

the shrill ring of a bell and a screech of delight, it becomes apparent that all along, the seawall has known its true purpose. About once every twenty years, it goes to work, but the rest of the time, this indefatigable sidewalk by the sea merely proves to us all that fun will always be timeless.

NOTES

Chapter 1

1. Cheesborough, "Some Inside Facts," 24.
2. Eisenhour, *Strand of Galveston*, 3.
3. Kelly, "'Twixt Failure and Success," 102.
4. Robert, Ripley and Noble, "Report to the Board," 5.
5. Ben C. Stuart, "Great Galveston Disaster," in Green and Kelly, *Through a Night of Horrors*, 96.
6. Margaret Rowan Bettencourt, "Margaret Rowan Bettencourt," in Green and Kelly, *Through a Night of Horrors*, 152.
7. Griffin, *History of Galveston*, 70.
8. Ibid., 72.
9. "Galveston to Be Rebuilt," *Galveston Daily News*, October 16, 1900.
10. Griffin, *History of Galveston*, 71.

Chapter 2

1. Griffin, *History of Galveston*, 70.
2. Kelly, "'Twixt Failure and Success," 104.
3. Stuart, "Galveston Disaster," 98.
4. Griffin, *History of Galveston*, 69.
5. "A Freight Conveyor," *Galveston Daily News*, January 25, 1901.
6. Kelly, "'Twixt Failure and Success," 103.

7. "Galveston's Brave Fight to Regain Lost Ground," *New York Times*, February 22, 1903.
8. Robert, Ripley and Noble, "Report to the Board," 11.
9. Griffin, *History of Galveston*, 74.
10. "Galveston—Aid of Donating Taxes for Fifteen Years."
11. "Galveston Seawall and Grade Raising," American Society of Civil Engineers.

Chapter 3

1. Robert, Ripley and Noble, "Report to the Board," 9.
2. Geographically, the thirty-two-mile-long barrier island of Galveston runs southwest to northeast along the curve of the Texas coastline, roughly fifty miles southeast of Houston. The original plat of the city was designed to run due east–west, which created directional references for the city that somewhat defy its geography. The "East End" of the city is technically on the northeastern point of the island; thus, the entire length of the island meets the Gulf of Mexico along its southern edge.
3. Griffin, *History of Galveston*, 76.
4. Wright-Gidley and Marines, *Galveston*, 15–24.

Chapter 4

1. Alvey, "Captain Alvey's Statement."
2. Located in the Galveston & Texas History Center of Rosenberg Library, Galveston, Texas.
3. "Filling from Gulf," *Galveston Daily News*, June 20, 1903. This article and others may be found in the first volume of the *Grade Raising Scrapbook*, edited by Edmond Cheesborough, located in the Rosenberg Library at the Galveston & Texas History Center, Galveston.
4. Cheesborough, "Advertisement, Instructions, Specifications and Proposal for Grade Raising Galveston, Texas," October 7, 1903.
5. "Raise the Grade," *Galveston Daily News*, December 8, 1903.
6. "Grade Canal Plan," *Galveston Daily News*, October 13, 1904.
7. "City Commissioners," *Galveston Daily News*, June 24, 1903.
8. "Raise City Grade and Cost of Same," *Galveston Daily News*, July 9, 1903.
9. Wright-Gidley and Marines, *Galveston*, 34.

Chapter 5

1. Quoted by Greene in "Electric Park."
2. Harvey, "Galveston Seawall."
3. Greene, "All but Forgotten."
4. Greene, "Electric Park Meant Electric Excitement for Galveston's Tourists."
5. Ibid., 3.
6. Greene, "Electric Park," 1.
7. Remark of newspaper editor during Texas Press Association's convention in Galveston, in Greene, "Chutes Park."
8. Greene, "Chutes Park," 1–3.
9. Ibid., "Seawall's First Test: Galveston's 1909 Storm."
10. Greene, "All but Forgotten," 2.
11. "Prefatory," *1908–1909 Galveston City Directory*, 4–5.

Chapter 6

1. "Prefatory," *1911–1912 Galveston City Directory*, 4.
2. Greene, "Electric Excitement," 2.
3. Ibid., "Pleasure Palace."
4. Ibid., "Handling the Multitudes."
5. Ibid., "Beacon in the Dark."
6. "Announcements," *Galveston Daily News*, January 26, 1912.
7. Greene, "Beacon in the Dark," 1–2.
8. Harvey, "Galveston Seawall," 5.
9. According to comparative data compiled from business listings in the *1916 Galveston City Directory*.
10. Greene, "Pleasure Palace," 2.
11. Maca, "Remembering the Crystal Palace."
12. Greene, "Reclaiming the Swamp."
13. Hall, "Galveston's Garden of Tokio."
14. Lauersdorf, "Galveston's Balinese Room."

Chapter 7

1. McComb, *Galveston*, 151.
2. Cartwright, *Galveston*, 212.
3. Lauersdorf, "Galveston's Balinese Room," 18.
4. "Bathing Girl Revue, To Be Riot of Color and Style, Will Be Held on Beach Today," *Galveston Daily News*, May 23, 1920.
5. Ibid.
6. "Bathing Girl Revue," *Galveston Tribune*, May 24, 1920.
7. "Bathing Girl Revue Draws Great Crowds," *Galveston Daily News*, May 24, 1920.
8. Ibid.
9. Ibid.
10. "Committee Will Ask Board for Concerts," *Galveston Daily News*, February 12, 1920.
11. Harvey, "Galveston Seawall," 8.
12. Greene, "Reclaiming the Swamp," 3.
13. Advertisement in the *Galveston Daily News* on July 14, 1921.
14. Lauersdorf, "Galveston's Balinese Room," 17.
15. Greene, "Reclaiming the Swamp," 3.
16. Rapier, "Memoirs of Virginia Harvey Rapier."
17. "King Cotton and Bathing Beauties Glorified in Local Fetes of Past," in "Beauty Contests" Vertical File.
18. Hall, "Galveston's Garden of Tokio," 90.
19. Adams, "Buccaneer Hotel."
20. Greene, "Handling the Multitudes," 2.
21. Ibid., 2.
22. Quote from *Galveston Daily News* of August 6, 1929, in Greene, "Handling the Multitudes," 2.
23. Greene, "Reclaiming the Swamp," 3.

Chapter 8

1. From Utley, *Lone Star Lawmen*, quoted in Lauersdorf, "Galveston's Balinese Room," 17.
2. Greene, "Reclaiming the Swamp," 3-4.
3. Hall, "Galveston's Garden of Tokio," 90.

4. "Tokio Skating Rink, 2114 Seawall Boulevard," listing, *1939 Galveston City Directory*, 467.
5. Harvey, "Galveston Seawall," 5.
6. McComb, *Galveston*, 34.
7. Lauersdorf, "Galveston's Balinese Room," 17.
8. "Introduction," *1930 Galveston City Directory*, 14.
9. Lauersdorf, "Galveston's Balinese Room," 18.
10. List of businesses compiled from the *1930, 1932–33* and *1938 Galveston City Directory*.
11. Greene, "Handling the Multitudes," 2.
12. Ibid, 3.
13. Harvey, "Galveston Seawall," 8.
14. "Introduction," *1930 Galveston City Directory*, 13.

Chapter 9

1. "Ornate Gates Purchased," *Galveston Daily News*, September 24, 1965.
2. "Introduction," *1941 Galveston City Directory*, 11.
3. The city of Galveston had a population of 37,789 in 1900. Comparatively, it numbered 49,608 in 2014.
4. Adams, "Jack Tar Hotel."
5. Greene, "Reclaiming the Swamp," 4.
6. Ibid., "Handling the Multitudes," 3–4.
7. Ferre, "Room With a View."
8. Lauersdorf, "Galveston's Balinese Room," 18.
9. Ibid.
10. "Introduction," *1943–1944 Galveston City Directory*, 14.
11. Pool (Galveston resident and examiner at Stewart Title Company), interview.
12. "Fort Crockett," *Galveston Daily News*, April 11, 1942.
13. "Stewart Beach Observes Second Anniversary," *Galveston Daily News*, July 18, 1943.
14. "WPB Authorizes Completion of Recreation Pier," *Galveston Daily News*, July 9, 1942.
15. McComb, *Galveston*, 154.
16. "Opening with a Splash," *Galveston Isle Magazine*, May 1948, 7.
17. Harvey, "Galveston Seawall," 5.
18. Greene, "Reclaiming the Swamp."

19. Callahan, "Along the Beachfront," *Galveston Magazine*, July 1947.
20. "Come to Galveston," 1948 advertisement in "Pleasure Pier" Vertical File.
21. Greene, "Reclaiming the Swamp," 5.
22. Ibid., "Handling the Multitudes," 4.
23. "Introduction," *1943–1944 Galveston City Directory*, 12.

Chapter 10

1. McComb, *Galveston*, 162.
2. Pool, interview.
3. "Scintillating Galveston," *Galveston Magazine*, June 1953, 18.
4. "Menard Park Improvements," *Galveston Tribune*, February 1, 1950.
5. "Scintillating Galveston," *Galveston Magazine*, June 1953, 18.
6. Whelton (Galveston native and former member of Road Runners car club), interview.
7. McLeod (Galveston native and owner of the former Bamboo Hut and Grass Menagerie on the seawall), interview.
8. "Cold, Creamy Triple XXX Offers Tangy Taste Thrill," *Galveston Daily News*, June 17, 1958.
9. "Surf Drive-In Barbecue Is Talk of the Town," *Galveston Daily News*, June 17, 1952.
10. McLeod, interview.
11. Freudenberg (Galveston native and owner of a custom car garage in the 1950s and '60s), interview.
12. Whelton, interview.
13. McLeod, interview.
14. Brown, "Free Rein," 118.
15. Lauersdorf, "Galveston's Balinese Room," 20.
16. Brown, "Free Rein," 120.
17. Ibid., 116.
18. "'Gay Nineties' Wedding Tonight," *Galveston Daily News*, July 11, 1957.
19. Harvey, "Galveston Seawall," 9.

Chapter 11

1. *Texas Magazine*, August 14, 1966.
2. Brown, "Free Rein," 121.

3. Harvey, "Galveston Seawall," 8.

4. Hodges, "Storm Data and Unusual Weather Phenomena."

5. Elder, "Luxury Lost."

6. Lestos (Galveston native and owner of the former Bamboo Hut and Grass Menagerie), interview.

7. Barrileaux, "History, Status of Flagship Hotel, City Contract Outlined."

8. "New Look on the Old Pleasure Pier," *Galveston Daily News*, June 20, 1965.

9. Stengler, "Oceanarium Got Off to Rocky Start."

10. "Introduction," *1968 Galveston City Directory*, xix.

11. Stengler, "Oceanarium," 1.

12. Hatch, "Author Tim Gould," 56.

13. "Balinese Room Could Give Beach That Extra Spark," *Galveston Daily News*, December 7, 1965.

14. "Sea-Arama One of Top Family Attractions in Nation," *Galveston Daily News*, February 22, 1970.

15. "Sea-Arama to Add Nine New Shows in 1969," *Galveston Daily News*, February 23, 1969.

16. "Killer Whale Mamuk Newest Super-Star," *Galveston Daily News*, February 23, 1969.

17. "Introduction," *1968 Galveston City Directory*, xix.

Chapter 12

1. Garcia, "Galveston's Attractions Par Excellence."

2. Listings, *1979 Galveston City Directory*.

3. "Chamber Group Urges Support for Westward Extension of Seawall," *Galveston Daily News*, November 13, 1973.

4. Kirkpatrick, "Extension of Isle Seawall Rejected."

5. "Introduction," *1979 Galveston City Directory*, xxi.

6. "Surfing Law, Central Plaza Zoning to Face Changes," *Galveston Daily News*, May 21, 1976.

7. Garcia, "Galveston's Attractions Par Excellence."

8. "Condo Fever—Catch It!," *Galveston Magazine*, Summer 1984, 46.

9. "Galveston on Verge of Building Boon," *Galveston Daily News*, August 16, 1981.

10. "Condo Fever," *Galveston Magazine*, 46.

11. Stengler, "Sidewalk Park Plan Proposed."

12. "Seawall Proposals Supported," *Galveston Daily News*, August 10, 1984.

13. Wittig, "Signs Were Not Needed."

14. Stengler, "City Given Help to Nip the Cost for Alcohol Ban."

15. Daugherty, "Police Gear Up for Crowd Problem."

16. Stengler, "Plans to Beautify Seawall Have Been Numerous."

Chapter 13

1. Desormeaux (Director of Operations, Island Famous Inc.), interview.

2. Elder, "Luxury Lost."

3. Thompson, "Landry's Hospitality Wants Flagship Operator out of Hotel."

4. Ibid.

5. Rice, "Galveston Project among Top 5 Restored Beaches."

BIBLIOGRAPHY

Books

1908–1909 Galveston City Directory. Galveston, TX: Morrison & Fourmy Directory Company, 1908.

1911–1912 Galveston City Directory. Galveston, TX: Morrison & Fourmy Directory Company, 1911.

1916 Galveston City Directory. Houston, TX: Morrison & Fourmy Directory Company, 1916.

1930 Galveston City Directory. Dallas, TX: Morrison & Fourmy Directory Company, 1930.

1932–1933 Galveston City Directory. Dallas, TX: Morrison & Fourmy Directory Company, 1932.

1938 Galveston City Directory. Dallas, TX: Morrison & Fourmy Directory Company, 1938.

1939 Galveston City Directory. Dallas, TX: Morrison & Fourmy Directory Company, 1939.

1941 Galveston City Directory. Dallas, TX: Morrison & Fourmy Directory Company, 1941.

1943–1944 Galveston City Directory. Dallas, TX: Morrison & Fourmy Directory Company, 1944.

1968 Galveston City Directory. Dallas, TX: R.L. Polk & Company, 1968.

1979 Galveston City Directory. Dallas, TX: R.L. Polk & Company, 1979.

Cartwright, Gary. *Galveston: A History of the Island*. New York: Athenaeum, 1991.

Eisenhour, Virginia. *The Strand of Galveston*. Galveston, TX: Self-published, 1973.

Greene, Casey, and Shelly Henley Kelly, eds. *Through a Night of Horrors*. College Station: Texas A&M University Press, 2000.

Griffin, S.C. *The History of Galveston*. Galveston, TX: A.H. Cawston, 1931.

McComb, David G. *Galveston: A History and a Guide*. Austin: Texas State Historical Association, 2000.

Utley, Robert M. *Lone Star Lawmen: The Second Century of the Texas Rangers*. New York: Berkley Books, 2007.

Wright-Gidley, Jodi, and Jennifer Marines. *Galveston: A City on Stilts*. Charleston, SC: Arcadia Publishing, 2008.

Newspaper and Magazine Articles

Adams, Katherine. "The Buccaneer Hotel." *Galveston Monthly*, May 2016.

———. "The Jack Tar Hotel." *Galveston Monthly*, February 2016.

Alvey, J.P. "Captain Alvey's Statement." *Galveston Daily News*, December 29, 1903.

Barrileaux, Gladys. "History, Status of Flagship Hotel, City Contract Outlined." *Galveston Daily News*, August 28, 1968.

Callahan, Steve. "Along the Beachfront." *Galveston Magazine*, July 1947.

Cheesborough, Edmond. "Some Inside Facts." *Galveston Daily News*, February 19, 1905.

"Come to Galveston." 1948 Advertisement. In "Pleasure Pier" Vertical File. Galveston & Texas History Center, Galveston, TX.

"Condo Fever—Catch It!" *Galveston Magazine*, Summer 1984.

Daugherty, Christi. "Police Gear Up for Crowd Problem." *Galveston Daily News*, May 7, 1989.

Elder, Laura. "Luxury Lost." *Galveston Daily News*, May 22, 2005.

Ferre, Nikkie. "Room with a View." *Galveston Daily News*, January 1, 2009.

Galveston Daily News. "Bathing Girl Revue, To Be Riot of Color and Style, Will Be Held on Beach Today." May 23, 1920.

———. "Bathing Girl Revue Draws Great Crowds." May 24, 1920.

———. "Chamber Group Urges Support for Westward Extension of Seawall." November 13, 1973.

———. "The City Commissioners." June 24, 1903.

———. "Cold, Creamy Triple XXX Offers Tangy Taste Thrill." June 17, 1958.

———. "Committee Will Ask Board for Concerts." February 12, 1920.

———. "A Freight Conveyor." January 25, 1901.

———. "Galveston on Verge of Building Boon." August 16, 1981.

———. "Galveston to Be Rebuilt." October 16, 1900.

———. "'Gay Nineties' Wedding Tonight." July 11, 1957.

———. "Grade Canal Plan." October 13, 1904.

———. "Killer Whale Mamuk Newest Super-Star." February 23, 1969.

———. "The New Look on the Old Pleasure Pier." June 20, 1965.

———. "Ornate Gates Purchased." September 24, 1965.

———. "Raise City Grade and Cost of Same." July 9, 1903.

———. "Raise the Grade." December 8, 1903.

———. "Sea-Arama One of Top Family Attractions in Nation." February 22, 1970.

———. "Sea-Arama to Add Nine New Shows in 1969." February 23, 1969.

———. "Seawall Proposals Supported." August 10, 1984.

———. "Stewart Beach Observes Second Anniversary." July 18, 1943.

———. "Surf Drive-In Barbecue Is Talk of the Town." June 17, 1952.

———. "Surfing Law, Central Plaza Zoning to Face Changes." May 21, 1976.

———. "WPB Authorizes Completion of Recreation Pier." July 9, 1942.

Galveston News. "Balinese Room Could Give Beach That Extra Spark." December 7, 1965.

Galveston Tribune. "Bathing Girl Revue." May 24, 1920.

———. "Menard Park Improvements." February 1, 1950.

Garcia, Deborah J. "Galveston's Attractions Par Excellence." *Galveston Magazine*, Summer 1985.

Hall, John. "Galveston's Garden of Tokio." *Galveston Monthly*, July 2016.

"King Cotton and Bathing Beauties Glorified in Local Fetes of Past." Article source unknown. "Beauty Contests" Vertical File. Galveston & Texas History Center, Galveston, TX.

Kirkpatrick, Joel. "Extension of Isle Seawall Rejected." *Galveston Daily News*, October 24, 1974.

Lauersdorf, Cheryl. "Galveston's Balinese Room Presents Bootleggers, Big Bands, and Headliners." *Touchstone* 32 (2013).

Maca, Kathleen. "Remembering the Crystal Palace." *Galveston Monthly*, June 2012.

New York Times. "Galveston's Brave Fight to Regain Lost Ground." February 22, 1903.

"Opening with a Splash." *Galveston Isle Magazine*, May 1948.

Rice, Harvey. "Galveston Project among Top 5 Restored Beaches." *Houston Chronicle*, May 25, 2015.

"Scintillating Galveston." *Galveston Magazine*, June 1953.

Stengler, Jack. "City Given Help to Nip the Cost for Alcohol Ban." *Galveston Daily News*, April 22, 1988.

———. "Oceanarium Got Off to Rocky Start." *Galveston Daily News,* January 29, 1990.

———. "Plans to Beautify Seawall Have Been Numerous." *Galveston Daily News,* March 3, 1991.

Thompson, Carter. "Landry's Hospitality Wants Flagship Operator Out of Hotel." *Galveston Daily News,* June 16, 2004.

Wittig, Mildred. "Signs Were Not Needed." *Galveston Daily News,* July 11, 1986.

Theses and Dissertations

Brown, Jean M. "Free Rein: Galveston Island's Alcohol, Gambling, and Prostitution Era, 1839–1957." Master's thesis, College of Graduate Studies at Lamar University, August 1998.

Kelly, Ruth Evelyn. "'Twixt Failure and Success, The Port of Galveston in the 19th Century." Master's thesis, University of Houston, 1975.

Papers Presented at a Meeting or Conference

Cheesborough, Edmond. "The Advertisement, Instructions, Specifications and Proposal for Grade Raising Galveston, Texas." Galveston & Texas History Center. Rosenberg Library, Galveston, October 7, 1903.

Harvey, Mark. "The Galveston Seawall." Coastal and Ocean Engineering Undergraduate Student Forum by Faculty of Engineering and Applied Science. Memorial University of Newfoundland, St. John's, NL, Canada, March 2013.

Hodges, Luther. "Storm Data and Unusual Weather Phenomena: September 1961." Report for United States Department of Commerce. National Climatic Data Center, Asheville, NC.

Robert, Henry, H.C. Ripley and Alfred Noble. "Report to the Board of Commissioners, City of Galveston." Galveston County Board of Engineers Papers, 1902–1926.

Articles in an Online Journal

Greene, Casey. "All but Forgotten: Galveston Auditorium." Online Exhibit of the Galveston & Texas History Center, Rosenberg Library, Galveston.

———. "Beacon in the Dark: Galveston's Slogan Sign." Online Exhibit of the Galveston & Texas History Center, Rosenberg Library, Galveston.

———. "Chutes Park Offered Beachgoers Waves of Summer Fun." Online Exhibit of the Galveston & Texas History Center, Rosenberg Library, Galveston.

———. "Electric Park." Online Exhibit of the Galveston & Texas History Center, Rosenberg Library, Galveston.

———. "Electric Park Meant Electric Excitement for Galveston's Tourists." Online Exhibit of the Galveston & Texas History Center, Rosenberg Library, Galveston.

———. "Handling the Multitudes: Traffic Control on Seawall Boulevard, 1911–1949." Online Exhibit of the Galveston & Texas History Center, Rosenberg Library, Galveston.

———. "Mountain Speedway." Online Exhibit of the Galveston & Texas History Center, Rosenberg Library, Galveston.

———. "Pleasure Palace: Galveston's Casino." Online Exhibit of the Galveston & Texas History Center, Rosenberg Library, Galveston.

———. "Reclaiming the Swamp, The East End Flats 1833–1954." Online Exhibit of the Galveston & Texas History Center, Rosenberg Library, Galveston.

———. "The Seawall's First Test: Galveston's 1909 Storm." Online Exhibit of the Galveston & Texas History Center, Rosenberg Library, Galveston.

Websites

"Galveston Seawall and Grade Raising." American Society of Civil Engineers. http://www.asce.org/project/galveston-seawall-and-grade-raising-project/.

"Online Exhibits." Galveston and Texas History Center. Rosenberg Library, Galveston. http://www.rosenberg-libary.org/collections/gthc/online/online.html.

Interviews

Desormeaux, Lauren. Interview by the author. January 2015.
Freudenberg, Henry. Interview by the author. September 19, 2016.
Lestos, George. Interview by the author. September 14, 2016.

McLeod, Doug. Interview by the author. September 12, 2016.

Pool, Donnie. Interview by the author. April 11, 2016.

Whelton, Bob. Interview by the author. September 16, 2016.

Other

Cheesborough, Edmond, ed. "Grade Raising Scrapbook, vol. 1, May 16, 1903–October 23, 1904." Galveston & Texas History Center. Rosenberg Library, Galveston.

"Galveston—Aid of Donating Taxes for Fifteen Years." Chapter VIII. General Laws, 28th Legislature, State of Texas.

Rapier, Virginia Harvey. "The Memoirs of Virginia Harvey Rapier." "Beauty Contests" Vertical File. Galveston & Texas History Center, Galveston, Texas.

INDEX

ABOUT THE AUTHOR

Kimber Fountain grew up on the Texas Gulf Coast and was a frequent visitor to Galveston as a child and a teen. After receiving a bachelor of arts degree in theater and dance from the University of Texas at Austin, she spent many years in Chicago before returning to Texas and making her present home on the island. Kimber has spent the past five years intently studying Galveston history within her work as a writer for several local publications and through her former position as a historical tour guide. She is currently the editor in chief and feature writer of *Galveston Monthly* magazine and serves as chairperson of the Arts and Historic Preservation Advisory Board to the Galveston City Council. Occasionally, Kimber can also be seen on stage at the Island East-End Theatre Company in downtown Galveston.